JUST DRAW!
A CREATIVE STEP-BY-STEP GUIDE FOR ARTISTS

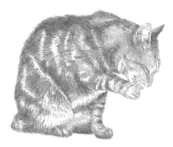

JUST DRAW!
A CREATIVE STEP-BY-STEP GUIDE FOR ARTISTS

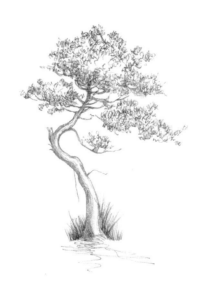

SUSIE HODGE

SIRIUS

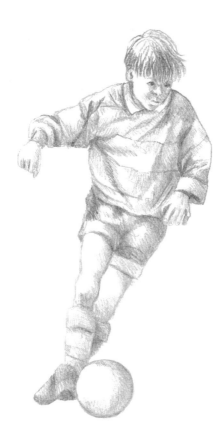

SIRIUS

This edition published in 2023 by Sirius Publishing, a division of
Arcturus Publishing Limited,
26/27 Bickels Yard, 151–153 Bermondsey Street,
London SE1 3HA

ISBN: 978-1-3988-2609-0
AD008599UK

Printed in China

Contents

Introduction

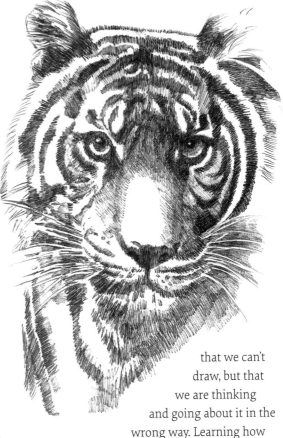

Everyone can draw – we can all learn how to do it and all of us can improve our drawing skills. All you need is the will to try and the patience to persevere. Of course, not all of us will become great artists, but most of us can learn to make marks that create sufficiently convincing and pleasing images – and to improve on these with practice.

Once you start creating those pleasing images on a regular basis, drawing becomes ever more rewarding. Those who are naturally skilled at drawing usually have excellent visual and spatial intelligence, and those who find it less easy simply need to spend more time developing and honing their proficiency. Research has shown that motivation is a fundamental factor in our ability to learn new things at any age. So, when it comes to drawing, a lot depends on determination and persistence.

As children, most of us love to draw, but from the age of about eleven, many of us become self-conscious about our drawing abilities, noticing our shortcomings and losing confidence. We also become busier with other things. Later however, the urge to create often arises again, but by then, many of us have lost faith in our drawing abilities, or just don't know how to go about it. Many adults unused to drawing feel unsure and inhibited. This self-doubt feeds itself into how individuals draw and can block progress, and it can feel frustrating when we can't convey visually what we're seeing or thinking. It's not that we can't draw, but that we are thinking and going about it in the wrong way. Learning how to draw and improving those skills can not only be rewarding in itself, but it can also have the benefit of boosting confidence in other ways.

Drawing the right way

Drawing can take up minutes, hours or even days of your time: it's up to you how long you dedicate to it. As a skill that can be learned, any time spent drawing is useful. Even if you're not pleased with the outcome at first, it is all worthwhile as you learn what worked well – or what went wrong. You learn where the mistakes occur and how to correct them, and the more you draw, the better you become.

This book will help you to go about drawing in a positive and productive way, and to overcome any doubts or difficulties you may have. It shows you how to build on existing skills, as well as gaining new abilities and refining them. It shows how you can spend just 15 minutes a day drawing almost any subject you choose, and if you follow the advice, you will improve and learn not only how to draw, but how to draw well.

Explore your creativity

Every day we are all overwhelmed by images – moving and still, public and personal. Some we seek out – such as in social media, in magazines, in the artwork on our walls or in our local scenery, while some simply surrounds us – such as in mass media or on advertising billboards.

Often, understandably, with this bombardment of the eyes, we mentally disconnect. Drawing – producing our own handmade images – can help to quieten our minds, to challenge ourselves, to explore our powers of observation and our own creativity, to express our emotions and ideas and to give us a sense of achievement.

In this book, you will discover how different methods of making marks on two-dimensional surfaces can result in images that we recognise, that please us and others, and that we are proud of. There are demonstrations, tips, suggestions and step-by-step projects that you can follow, from first marks to final images. These will all help you to understand ways of looking and drawing, and to develop your own style as you progress from basic drawings to more complex and intricate images.

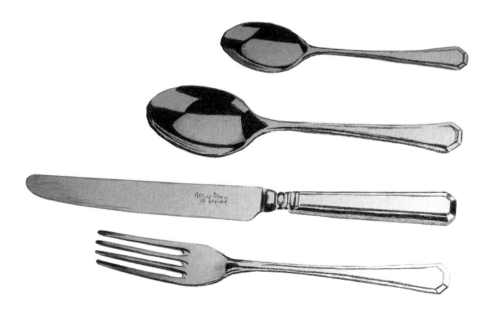

How to Use This book

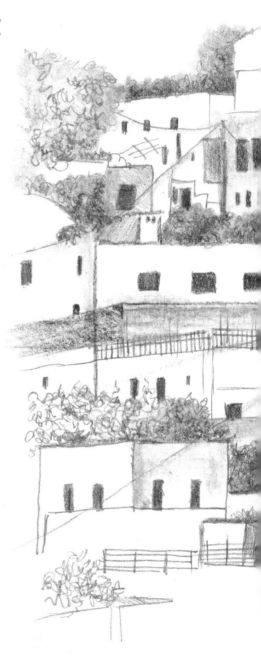

Nearly everything manmade began with a drawing; from a toothbrush to a chair, a flowerpot to a spaceship. Drawing is the root of all art forms – a skill that all artists and designers need, whatever their specialism, and an essential and rewarding way to communicate visions, feelings and ideas. Drawing can open your eyes to many things. It makes you more observant and it makes you look at the world differently. This book is here to help you to draw, and to keep improving. You can follow it through, page by page chronologically, or you can dip in and out of it. The straightforward, page by page method will probably reward you with the most benefits soonest, but use it in the best way for you, depending on how much time you can afford. It should be fun and enjoyable. Learning to draw is a process and most of the drawings and projects included, can be drawn in minutes rather than hours. Fifteen minutes a day will be enough, although if you have more time to spare, of course, that will always be even more beneficial.

Believe in yourself

This book intends to help you draw with confidence. By the time you have read it and put into practice some – or preferably all – of the suggestions and projects, you should be able to draw anything with a belief in yourself and your own abilities. As you read the book and build your skills, feel free to draw, sketch or doodle on the pages, or to make notes on them. Also draw elsewhere; in sketchbooks, on loose paper or on any surface that suits you. Use any materials you like for your drawing, but if you want to erase any of your work, use a soft pencil, such as a 2B or 3B, as harder pencils and other materials will leave marks

or indents (see pages 12–15 for more on drawing implements).

Feel free to read through the book as you prefer. You can read it from cover to cover or dip in and out. You can try a project, go back to an earlier page, jump forward, or work in any way that suits you – although it will be more straightforward if you read it from beginning to end. However you read it, be sure to draw as you go. As with any activity, drawing skills need practice to be improved. Follow the suggestions, projects and exercises, and don't worry about making mistakes. Only by making mistakes and correcting them can any of us improve; it's all part of the learning process. As you become more skilled, you will be able to see where you need to amend and you will draw more fluently.

What to do next

This book is written so that you can start drawing right now. It begins with information on drawing materials, followed by methods for quick sketches, speedy warming-up ideas, techniques for adding tone, and exercises for getting used to the feel and process of drawing.

Throughout, there are plenty of tips for developing and enhancing your skills and exercises to help you gain confidence. The final section features projects that you can practise and expand upon, and when you feel more confident, you can adapt the techniques to create your own drawings. Some of the projects are quick, using loose and expressive lines, and some are more detailed and will take longer. Always remember that there is no single or correct style of drawing; we all draw in personal ways, and your own distinctive style will emerge as you practise.

It's up to you how much or how little you do. You might want to set aside a certain time each day, week or month, or to draw as and when you can find the time. If you are really serious about improving your drawing skills, you'll need to draw often – as you are learning a new visual language. Draw on your own, or work through the book together with friends. Arrange to meet regularly – in person or online – to compare, discuss and maybe critique what you have each produced. Always remember why you want to draw and what you hope to achieve from it.

Are you sitting comfortably?

Before you begin, think about where you draw and your posture. Do you stand or sit? If you stand, are you upright, or do you arch your back? If you sit, can you see your work without bending over and hurting your neck and shoulders? Good posture is important. Make sure you are comfortable, but without straining any muscles, including your eyes. Keep a good light on your work so you can see it clearly. The light should be bright enough not to tire your eyes, but not so bright that you cast a deep shadow over your drawing.

Drawing Implements

Drawing should never feel boring, because you are always learning and your results constantly evolve. Every time you make a mark as part of a drawing, you are create and understand more.

Experimenting with marks and materials is a great way to discover what suits you best. First, choose your materials – consider pencils, charcoal, fine liners or ballpoint pens, for instance.

Pencils

If you are working with pencil, find one that you feel comfortable with. B pencils are the softest and make darker, blacker marks than H pencils. The number next to the B indicates how black, so for example, a 6B is softer and darker than a 2B. 9B to 5B are particularly soft pencils that make dark lines and the deepest, blackest tones. Their soft lead will wear down quickly and glide over your paper or whatever surface you are using, but take care as they also smudge easily. 2B and 3B pencils are versatile and good for general drawing and quick sketches. They will give you a fairly dark line, but not the blackest tones. The HB is the standard pencil. It falls between soft – B, and hard – H. It can be used for sketching and for making a variety of marks, including smooth, fine lines, but it is not so useful for shading as the softer pencils. Pencils graded with an H are hard. They rarely need sharpening, and create light, smooth lines. Unless you work with an extremely light touch when using them, they will indent your paper. H pencils and mechanical pencils (those with a replaceable lead) are best for detailed, precise drawings.

Charcoal and charcoal pencils

One of the oldest drawing implements that has been used by humans for tens of thousands of years, charcoal is black, smudgy and soft, generally obtained from the burning of materials such as wood, peat and cellulose, and is usually mixed with clay, formed into sticks. Ideal for making a variety of quick marks, charcoal can be smudged or blended with a paper torchon, or lifted with a putty eraser. Its versatility allows you to produce a variety of effects quickly using little pressure.

Charcoal pencils are charcoal sticks encased in wood. With a fine texture and ease of use, like the sticks, charcoal pencils are versatile and impart a rich black colour. Like ordinary graphite pencils, there are different softnesses of both charcoal and charcoal pencils.

Pencil grip

Next, think about
how you hold your
pencil. There are
three main ways of
doing this.

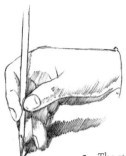
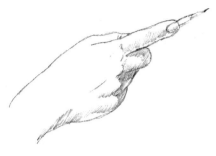

1. *The standard writing grip will give you controlled lines, which are good for detailed drawing, close hatching and so on.*

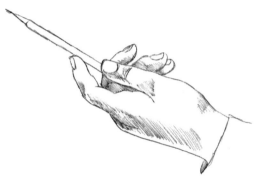

2. *If you turn your hand so the back of it is facing your paper and hold your pencil in the palm of your hand, between your thumb and forefinger, you will be able to create free, loose and sweeping marks but you will have less control.*

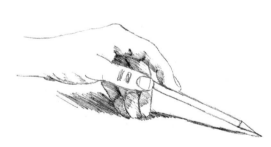

3. *Another way of holding your pencil – or other drawing implement – is to cover it with your hand, palm face down, so that the entire stem of the pencil is covered by your hand. With this method, you will find that you can lay down areas of tone quickly and easily and you can draw the main contours of a drawing well. An important advantage of this technique is that your palm does not touch the paper, so you won't smudge your drawing.*

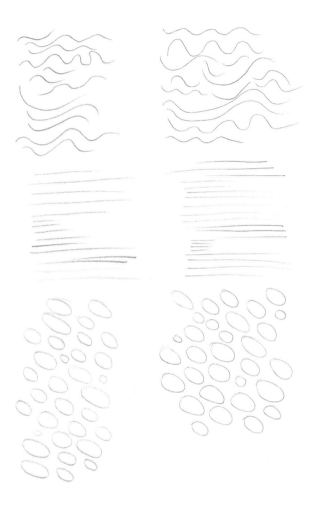

Some of these positions may feel strange at first, but each has its benefits. Whichever position you use, don't grip your drawing implement too tightly; your hand should not feel strained.

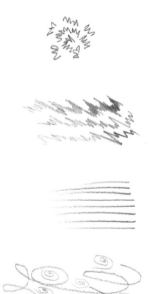

Make lines and marks with a range of pencils, charcoal or charcoal pencils. Here are some ideas to get you started:

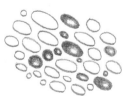

Try your own doodles here:

Pens and inks

There is a range of pens and brushes available for making ink drawings. Try out dip-pens with nibs of different shapes and widths, fountain or cartridge pens, ballpoint or technical pens, or brushes with a good point. Black or brown ink is most commonly used for ink drawings, and if you have ink in a pot, it can be diluted and spread with the tip of a brush dipped in water. Thicker, smooth paper is preferable to thin, lightweight or rough paper, especially if you are using a brush.

As with all drawing materials, experiment before you decide what you prefer – and don't always assume that the most expensive are best.

When you initially draw with ink, try making a light pencil sketch first. The pencil marks can be erased once your ink drawing is dry, but tell yourself not to worry about making mistakes.

To create darker tones in ink, use stippling (dotting), hatching (parallel lines) or cross-hatching (criss-crossed lines). See pages 32–33 for more on these techniques. For weightier lines, layer rather than press harder. With ballpoint pen however, a certain amount of shading can be achieved through varying the pressure.

Clean ink pen nibs with a damp cloth, and as you work with a pen, remind yourself to hold it at approximately a 45 degree angle to your paper.

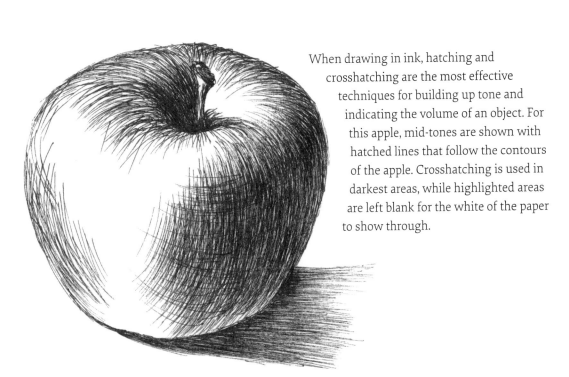

When drawing in ink, hatching and crosshatching are the most effective techniques for building up tone and indicating the volume of an object. For this apple, mid-tones are shown with hatched lines that follow the contours of the apple. Crosshatching is used in darkest areas, while highlighted areas are left blank for the white of the paper to show through.

Make some pen drawings here:

Quick Sketches

Quick sketches are a great way to start drawing. They will help you to loosen up, to really feel the drawing implement you are using and to get used to making marks with it.

When you begin, don't worry about what your sketches look like. They are for your eyes only – unless you choose to share them – so relax. Draw what you see, without thinking about the marks you are making. You are making notes, creating a visual shorthand account of what you are looking at, nothing more. All famous artists have made sketches; some more detailed and precise than others.

Warming up

Every drawing, every sketch begins with a mark, and to make sure that they are as assured as possible, warming up can be helpful. Drawing simple lines and shapes will help to improve your control, and this will make your work more fluid and dynamic. Hold your drawing implement firmly, but keep your wrist fairly flexible as you make your marks, and let them flow. Keep your drawing hand off the paper so you don't smudge, and use firmer and lighter pressure to create darker and lighter marks.

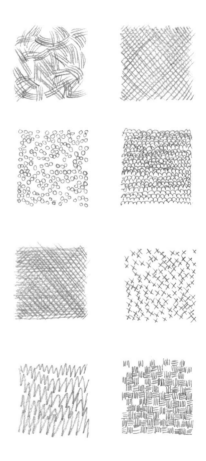

Divide your page into square or rectangular boxes into at least six areas or boxes, and try some of these ideas:

Enjoy these exercises. The more you do them, the more confident you will become with making different types of marks that can all be used in your finished drawings.

Eraser drawing

Make sketches anywhere you can.
Don't worry if your paper or sketchbook
gets a bit tatty. Work as quickly as possible
and don't focus on any one area for too
long. Some of the sketches in this chapter
were made while abroad, often in windy
conditions, and they had to be put down
frequently, then picked up again later.
Some are more detailed than others.
Most use scribble marks and quick lines.

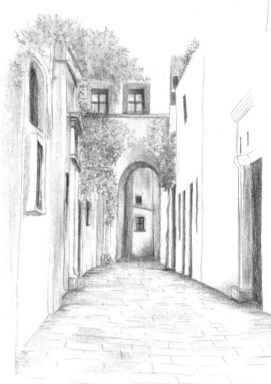

One of the speediest ways to create tonal
contrasts (while sketching outdoors, for
example) is to take a soft eraser and use it to
gently blend and spread some of the graphite
from your pencil. You can see this method has
been used in the sketch of buildings in Lindos,
Rhodes, drawn from the beach (see page 10), on
the shaded parts of the white buildings and the
plants growing around them.

Erasers can also be used to create
highlights by lifting parts of pencil- or
charcoal-shaded surfaces. Use a soft eraser or
a kneadable putty eraser, which can be shaped
and then rubbed gently in some areas, or
pressed and lifted where necessary. Depending
on how much pressure you apply to the eraser,
you can create lighter or darker areas.

Looking and Seeing

Drawing relies on your ability to draw what you actually see and not what you *think* you see. Most of us allow our memories and thoughts to interfere with our drawing; we tend to put marks in certain places that are actually incorrect because we have preconceived ideas about our subjects. So one of the first skills to cultivate is the ability to see objectively; to observe calmly and clearly and to make marks based on what is in front of you.

When you draw what you see, your eyes spend at least the same amount of time looking at the object you're drawing as at the drawing itself – sometimes even more. As you work, your eyes should move back and forth from your subject to your drawing, constantly comparing the two.

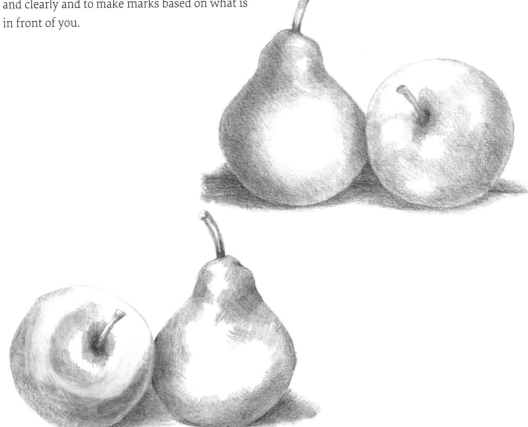

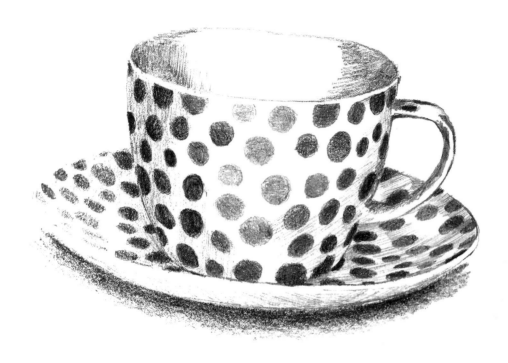

Break it down

Try not to worrk about whether your drawing looks like the object, person or place it is meant to be. If you focus on drawing just the shapes spaces and angles you see, you will get there. Look for the shapes both in and around whatever you are drawing. Look for angled lines, curves, widths, heights, comparative ratios and lengths.

As you draw, keep checking what you are seeing and check with yourself, such thoughts as: 'Is this line long enough? Does that angle match the angle on the other side? Does this curve match the curve above or is it deeper? Is this line straight or does it bend? Is this shape larger than the other similar shape opposite?'

Try to practice this exercise in observation every day. You can do it even when you are not drawing: just look at things and really see them.

Observation

First, choose something that interests you. This can be anything from a piece of fruit to a tree, your pet, or an entire scene. Place your sketchbook or paper where you can move your eyes constantly from your subject to your drawing.

- Begin by focusing on the larger shapes of your subject. Work loosely and mark on the basic forms before worrying about any details. Look for the darker areas and consider building your sketch with shadows and light rather than outlines.
- To work out rough proportions, check how things relate to each other. For example, compare angles and lengths, or the sizes of different shapes.
- Use varied lines to create interest, and try not to smudge your marks. A clean sheet of paper placed under your drawing hand will reduce this.
- Never try to draw every detail; you won't do this even in a finished drawing and it is certainly not necessary to replicate every leaf or strand of fur, for example. You just need to give a general idea, and this is where the boxes of marks on page 16 are particularly helpful. Practise them to convey the overall idea of what you are looking at and to build a sense of texture quickly and effectively. Does your subject have rough or smooth areas, and where does it absorb or reflect light?

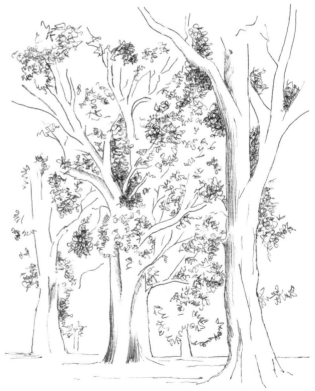

Here is a sketch of trees that has been started, but not completed, so you can see the marks used to denote leaves (squiggles and rough triangles) and bark (fine vertical hatching). In the darker areas these marks are clustered more densely, while lighter areas are left blank.

Make your own observational sketch here:

The Sighting Method

This method can be extremely helpful to determine sizes and proportions of what you are drawing or sketching. It's a technique that has been used by artists throughout history.

1. *Press your spine against the back of your chair and hold a pencil vertically in your hand between your thumb and fingers. Extend the arm that is holding the pencil forward, and keep it straight. Close one eye.*

2. *Align the tip of your vertical pencil in your extended arm with the top of the subject you are drawing. Keeping one eye closed, slide your thumb down your pencil until it aligns with the bottom of your subject.*

3. *Keep your thumb in place and move your pencil to your paper. Make a mark at the top of your pencil, and another where your thumb is. You now have the top and bottom of your subject. (You can open both eyes to do this!)*

4. *Return your body to the same position, with your back flattened against the back of your chair, your arm extended and your eye shut. You can turn your pencil to gauge horizontal measurements, using the same technique. Continue to take measurements from all over your subject until you feel you have enough information to start drawing.*

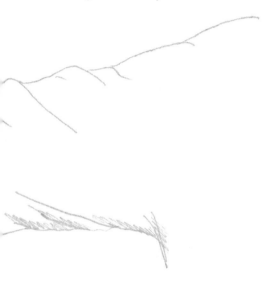

Making it (Look) Real

Drawing is a creative way of seeing. You might think that you have observed something by looking at it closely, but, when you come to draw it, you discover even more. This is why sketching and drawing can prove to be a revelation, giving you a connection with your subject both visually and emotionally. Whenever we draw or sketch something, we learn about form, proportion, structure, spatial relationships, perspective, texture and tone. Additionally, unlike a photograph, with a drawing, you can concentrate on what interests you and omit or minimise what doesn't.

Whether you are drawing from life or from photographs, there are ways that you can make your images look more lifelike and convincing. Over the next few pages we will explore some of these techniques in more detail.

Negative space

When you observe your subject, the first elements to look for are proportions and angles, but also negative spaces. These are the spaces around and sometimes between what you are drawing.

In this finished drawing of a glass bottle, the silhouette of the whole shape was created by looking at the curved spaces around it, including its rounded lid and shoulders and between the base of the bottle and the shadow.

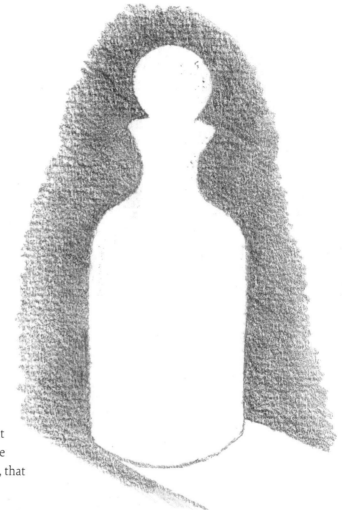

In the negative drawing of the bottle, the dark area indicates negative space. There is no detail in this drawing, but the negative space creates an accurate silhouette of the bottle. So negative drawing shows the space around things; by drawing it you will create the correct shape of the object, person, or animal, for instance, that you are drawing.

Drawing negative space is a perceptual tool that you should try to integrate into your regular drawing practice. It helps to switch off your memories, consciousness and subjectivity of what you are drawing into an objective exercise, which all helps to make drawings look more lifelike.

Tonal contrasts

Tone is the relative scale of light to dark values in an image. It is essential for creating the appearance of depth and solidity in your drawing. Showing tonal contrasts can change a flat-looking drawing into a convincing, three-dimensional image.

As before, try dividing your page into boxes or sections and in each, practise ways of shading to create tonal contrasts. You can do this with smooth, even shading, or with hatching or crosshatching, stippling, or any other method you prefer. Whatever marks you make, apply them as evenly as possible to create a smooth transition from light to dark.

Creating tonal contrasts

By working carefully and with a light touch, you will be able to build up a range of tones that will enhance your drawings and portray a sense of depth and three dimensions.

Blending

To create smooth transitions from light to shadow, use uniform blending, either rendering in straight lines or in small circles, layering if necessary.

Gradating

To create smooth changes from light to dark, apply little pressure at first, then gradually become firmer and add more layers to create a sense of greater depth. You can also shade from dark to light, starting with firmer pressure and gradually becoming lighter.

Consider your lighting

When you are drawing, be aware of where the light is coming from. It could be coming from several sources and directions and it may be a mix of natural and artificial. Try to identify the brightest, lightest areas, the mid-tones, and the darkest areas. Areas of darker tone in your drawing might come from:

• Local colour – this is the actual colour of an object. For instance, if you are drawing a dark garden fence or a black dog.

• Cast shadows – this is the colour that is created when light is blocked.

• Reflected colour or shade – this is where one object receives the reflection of another object. For instance, if an orange is in a blue bowl, some of the blue might reflect on the orange.

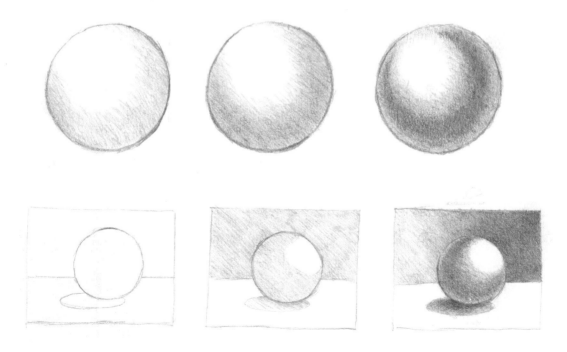

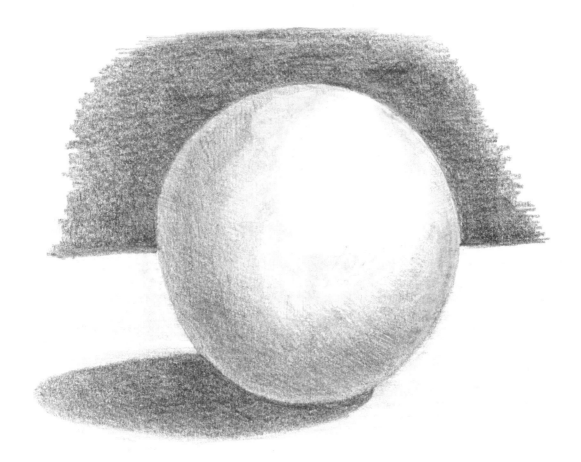

In this sphere, there is one light source, coming from the top right, which is why the top right of the ball has been left white. The bottom of the sphere has also been left white to show reflected light. The darkest tones are in the sphere's cast shadow beneath it, while the mid-tones are in areas that are only partially lit, either from cast or reflected shadows, and these are carefully blended to give the impression of a smooth, curving surface.

Tonal drawing exercise

A good exercise you can do to become used to working out the sizes, shapes and placement of tones, is to create purely tonal drawings with no outlines, as here with the pear and apple.

1. *Observe carefully the areas of light and shadow on the fruit. Use shading – but no outlines – to build up a sense of the forms. Here, diagonal hatching in pencil has been used to indicate tone.*

2. *Continue shading, by layering and blending the areas of tone. For the darkest areas – around the bottom edges of the fruit and at the base of the stems – apply a little more pressure with your pencil to lay tone more densely. Leave the lightest areas blank; these are the highlights.*

Squinting

By half-closing your eyes when you look at what you are drawing, you will block out small details and will see the overall dark and light tones more clearly. By squinting like this, you will be able to see three main tonal contrasts: the darkest tones, the brightest highlights and the mid-tones. As a general rule, work from dark to light and use a light touch; it is easier to go darker over a drawing than to lighten it.

It would be impossible for us to draw every tonal value that we see in real life, so it is best to simplify your drawings into three shades: light, medium and dark. When you start drawing with tone, pick something relatively simple, such as a piece or small bunch of fruit, a leaf or a box – you can move on to more complex subjects when you feel ready. As you can see with this pair of cherries, you cn get a good result by carefully rendering of the areas of tone and leaving the brightest highlights blank.

Try different ways of shading and creating the sense of tonal contrasts.
The following techniques can be used with pens as well as pencil.

Hatching

Draw parallel lines – close together for
deeper, darker shading, and further apart
for lighter. Use a sharp point or fineliner
for ultra-fine hatched marks and softer,
wider strokes for less detailed hatching.
Press harder for darker tones.

Crosshatching

Begin with hatched lines in one
direction, then more in the opposite
direction. Once again, the closer
together or darker the lines, the
darker and deeper your tones will be.

Stippling

Create stippling marks with dots, close together
for darker tones, further apart with fewer dots for
lighter. Depending on how uniform or otherwise
your marks are, the shaded area will seem either
smooth or bumpy and uneven.

Practise here:

By varying the tones in your drawings, from light to mid, to dark, you can create all kinds of effects. You can use the side of your pencil or smudge with charcoal or chalk, or blend gently with ballpoint pen. If you are using pen and ink or a fineliner, you will need to make marks such as hatching, seen here with this tiger:

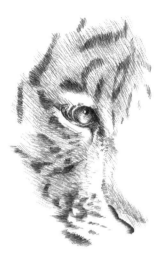

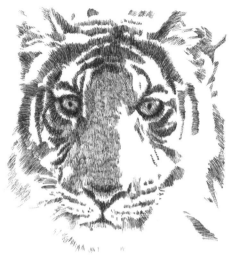

The marks on this tiger work to show both tone and the animal's markings.

Practise here:

Texture

Whatever you are drawing, from the rough bark of a tree to a smooth porcelain jug, you need to be able to render texture.

The appearance – or illusion – of texture helps viewers to understand the feel of the surface being portrayed. Texture applies to every surface: delicate shells, coarse matting, springy grass, soft velvet, hard metal, shimmering water – all give visual signs of what they feel like. If you can recreate the look of texture convincingly, you will add a huge amount of interest and realism to a drawing.

Textures can be rough or smooth, hard or soft, regular or irregular, wet or dry, natural or manmade – and more. To create these different appearances, a variety of techniques can be used. The varied marks on page 17, and the hatching, crosshatching and stippling on pages 30–1 can all be used to denote texture, as well as the patterns shown below.

Try using contrasting or repetitive marks. Squint your eyes and notice the overall patterns of the appearance of the texture. Experiment with a variety of different marks, as here:

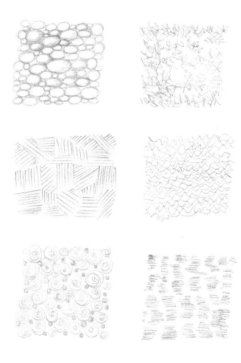

At right are some more ideas for you to follow. As you can see, the variations of pattern and texture are endless.

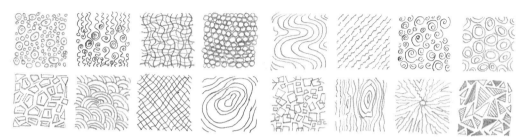

Practise here:

The fall of light

First of all, pay attention to where the light falls on your subject. The shaded areas (where the light does not fall) will be where you make most of your marks.

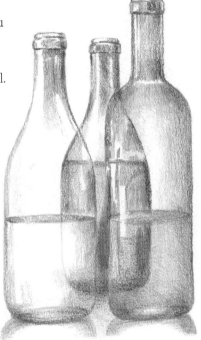

Look at these glass bottles, rendered in charcoal. Glass is usually transparent where the light shines, although in these bottles, there are reflections and cast shadows as well as liquid inside them. Where the light does not fall, the bottles are dark.

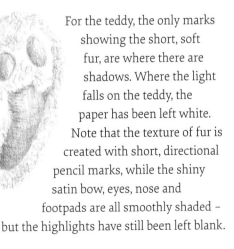

For the teddy, the only marks showing the short, soft fur, are where there are shadows. Where the light falls on the teddy, the paper has been left white. Note that the texture of fur is created with short, directional pencil marks, while the shiny satin bow, eyes, nose and footpads are all smoothly shaded – but the highlights have still been left blank.

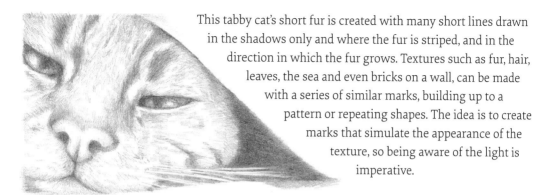

This tabby cat's short fur is created with many short lines drawn in the shadows only and where the fur is striped, and in the direction in which the fur grows. Textures such as fur, hair, leaves, the sea and even bricks on a wall, can be made with a series of similar marks, building up to a pattern or repeating shapes. The idea is to create marks that simulate the appearance of the texture, so being aware of the light is imperative.

For shiny objects such as this metal cutlery, the contrast between light and dark is usually more marked than on non-shiny objects. Here, the shapes of the areas of highlight and shadow are vital to understanding the whole form of each item of cutlery.

The focus in all of these examples is on marks that simulate the appearance of the texture, so being aware of the fall of light is imperative.

Practise your own drawing here:

Patterns

To create interest and realism, objects in the background of a drawing should be drawn with softer textural marks than those in the foreground. Similarly, objects that are the main focus of your image should have more detailed textural marks.

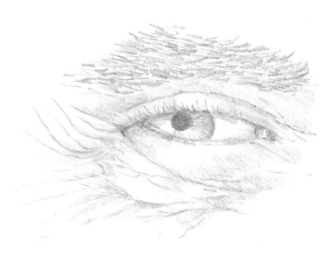

All textures follow particular directions. Think of tree bark, shells, fur, feathers, leaves, fabrics, hair and wrinkles: each of those have markings that fall in specific ways. So they need to be drawn in the directions they fall or grow in. Look at this close-up drawing of a wrinkled eye: the creases in the skin follow the contours of the eye, and the hairs in the eyebrow all point in the direction of growth. The eyelashes, though short, have a different direction of growth that adds liveliness to the eye.

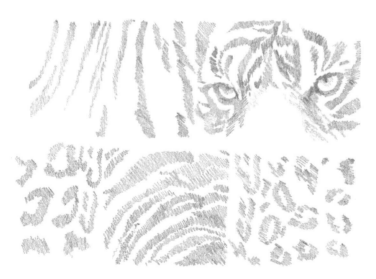

Likewise, in these studies of animal markings, all of the pencil marks follow the direction of growth of the fur. In the close-up drawing of a tiger there is no overall shape to help identify the animal, but the stripes, drawn in short hatched lines, give form and identity that make the animal recognizable.

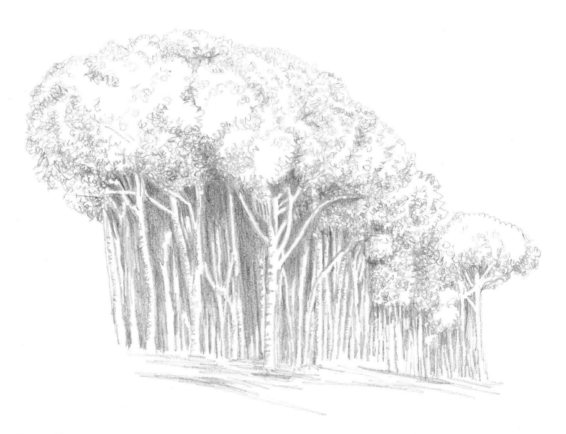

Repeating patterns

Look for subjects that can be drawn with recurring, general patterns, as you certainly don't need to draw, for example, every leaf on a tree, every hair on a person's head, or every cloud in the sky. Instead, shorthand patterns will convey the general idea of what you are drawing.

By making marks near the foreground larger than marks and patterns in the background, you will be complying with the rules of perspective (see pages 46–51). For this, you can experiment with varied pencil grades as well as different marks; harder pencils used in the background will appear lighter in tone, and softer pencils in the foreground will create darker, more prominent tones.

In this group of trees, there are two main areas of textural marks: the clumps of leaves across the top of the drawing, and the massed vertical trunks below. None of these marks are particularly precise, but the combinations of repeating shapes give a clear and realistic impression of trees.

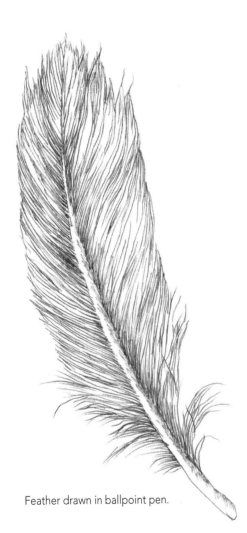

Feather drawn in ballpoint pen.

Creating textures with different materials

If you are using pen and ink or ballpoint pen instead of pencil, you can still make marks to convey textures, only you will not be able to blend them in the same way. Instead, try stippling, hatching or crosshatching, short and long broken marks, or scribbled lines.

If you are using charcoal, you can smudge to blend your marks. Generally, charcoal drawings need to be fairly large and details will be minimal, but the effects of texture can still be created. Try working on coloured paper and use charcoal with white chalk so that you can create highlights with the chalk.

Because each type of texture requires a different technique, they can be fun to draw and add interest to drawings. Some textures need a combination of techniques to be credible. One of the best ways to learn how to draw textures is to simply gather several objects and keep drawing them, over and over. Here is a selection of different objects to give you some ideas.

Shell in pencil and pen. For this drawing, a sharp B pencil was used to create the form, with a fine nibbed black fineliner for the details.

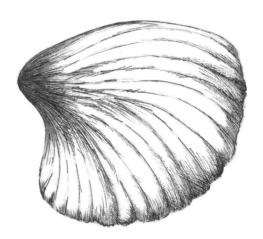

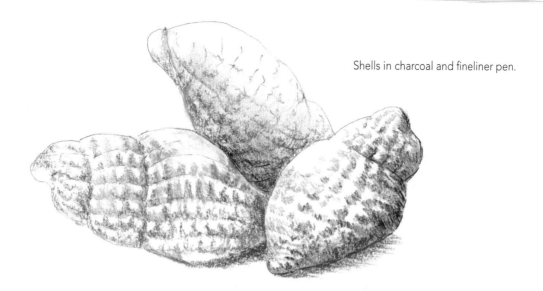

Shells in charcoal and fineliner pen.

Practise your own textures here:

Line

While you can draw with tonal contrasts alone and no outlines (see page 27), most of us draw with lines. Lines can achieve a great deal in drawings: they can build a sense of perspective, distance, direction, shape, form, and dimensions. They can also divide space and create texture and pattern. Above all, drawing with lines and contours can give the artist a sense of control.

There are several different types of line in drawings. For example, contour lines describe the edges of shapes, while gestural lines can describe movement. Implied lines give a suggestion of what might be there, parallel lines form hatched marks for shading and other lines can include, for example, continuous lines, thick lines, broken or fine lines, and many more.

Expressive lines

Lines can also convey moods, emotions and feelings as varied as tranquillity, vitality, hope, happiness, despair or anger. They can be elegant and flowing or jagged and irregular, thick or thin, unbroken or fragmented. Horizontal lines can convey stability and calmness, while vertical lines can create the illusion of height, and diagonal lines can suggest action and energy. You can vary the length, width, tone and texture of your lines, make them curve or zigzag for instance.

Lines can also be used for hatching or crosshatching, and in various other ways to convey textures (see pages 38–9).

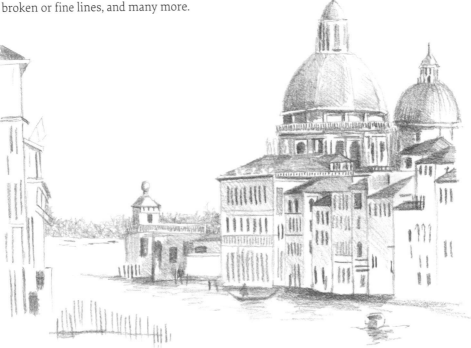

This sketch of the Grand Canal in Venice was created with lines only. Lines in different strengths and directions indicate the forms of the buildings, boats and water, the many windows and vegetation in the distance. Even the darker tones were created with hatched lines.

This bowl of cherries began as a simple line drawing – the outline was created first. Once the lines were in place and accurately portrayed the forms of the bowl and cherries, then shading was added using B, 2B and 4B pencils. When making your own drawing, remember to look for the negative shapes and make a light outline using a soft pencil. Once you are happy with your outlines, then build up the darkest tones, leaving the white of the paper showing through for highlights.

Shape and Form

Most of us think of objects as we see them straight on – directly from the front. However, we often see things from different angles, meaning their shapes appear to change. Observing what we can actually see, rather than thinking we know it already, can throw up surprises.

Try drawing some simple objects from different viewpoints. For example, place a phone, a biscuit, a book or a banana on the table in front of you. Draw it straight on and notice its shape and the negative space around it. Then move it. Put it on a box, push it to one side, tilt it. Then draw it again. Do this at least three times.

If you feel unsure about doing this, spend time just looking, comparing the object's shapes with the table beneath it, the background around it. Only begin to make marks once you feel sure of the shapes and angles you can see.

Once you are confident drawing single objects in this way, do the same with a group of them; a bowl of fruit, a tray of tea cups or mugs, a pile of books or a vase of flowers – all simple, household objects – and carefully observe their changing angles. This will help your powers of observation and your ability to measure angles and shapes by eye.

Basic shapes

If you break them down in your mind's eye, many objects are made up of simple shapes. For instance, a pear is roughly triangular, while oranges, apples, plums, peaches, melons, cauliflowers and cabbages are roughly circular. Mugs, jars and bottles are

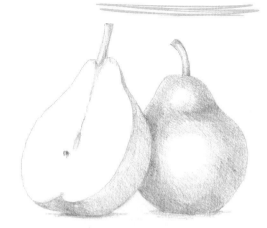

cylindrical, and most books, phones, televisions, computer screens and keyboards are rectangular. Everything can be seen – and drawn – as these simplified shapes. One of the first artists to draw objects as simple geometric shapes was Paul Cézanne (1839–1906), who wrote: 'Treat nature in terms of the cylinder, the sphere and the cone.'

By identifying and drawing the shapes of your subjects, you will soon incorporate aspects of perspective, even if you don't realise you are doing it. This will help to give your drawings a sense of depth and distance. The exercise will also make you more aware of composition. When you draw more than one object, you will put them into some sort of arrangement. By studying the shapes, forms, negative spaces and angles made by these objects, you will discover what works and what is not so effective. See pages 46-47 for perspective and 52-7 for more about compositional arrangements.

Practise here:

Modifying shapes and forms

By viewing everything you look at as shapes with
two dimensions, and form with three dimensions,
you will understand more clearly how they alter as
your viewpoint of them changes. For example, when you look at a
cup from directly above, it is a circle, but when you view it from a
lower angle, it becomes an ellipse. If you look at your pet cat from the
side, it has a roughly circular head with a small triangular nose and
mouth, and an oval body. However, if the cat faces you directly, the
head and body become small and larger circles respectively.

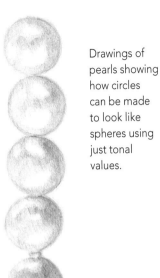

Drawings of
pearls showing
how circles
can be made
to look like
spheres using
just tonal
values.

Flat shapes to 3D forms

Flat shapes such as triangles and squares can be turned into their
equivalent forms of pyramids and cubes by adding further lines.
Shading will contribute to a sense of volume, but it is not always
necessary. However, to give a circle the appearance of a three-
dimensional sphere, shading is essential.

Angled viewpoints

When regular shapes such as circles and squares are seen
from an angle, their shapes change. So, for example, circles
become ellipses and squares become trapezoids. Being able to
draw all these shapes comfortably is a valuable skill to have.
Practise them as often as you can, without using any rulers or
compasses.

Ellipses are the shapes you will see most often when
drawing circular objects such as jars, bottles, canisters, sieves,
saucepans, plant pots, plates, saucers, teacups, mugs, glasses,
round tins and mirrors. Ellipses change shape according to
your viewpoint, as you can see in the two drawings of teacups
below. If your eye level is high, the ellipse will be fat, closer
to the circle of the actual shape. If your viewpoint is low, the
ellipse will narrow.

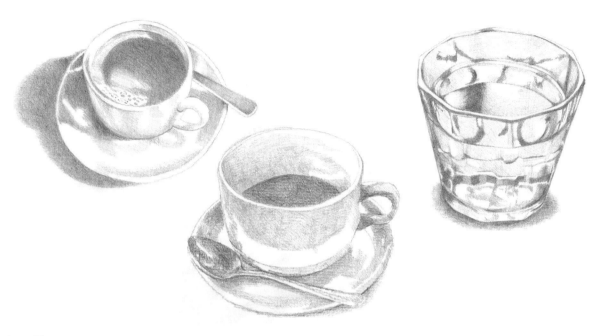

Practise drawing some shapes and forms here:

Perspective

The use of perspective will give your drawings the appearance of depth and distance, by showing Although the ancient Greeks and Romans understood both linear and atmospheric perspective, over time, their knowledge was lost. It is generally accepted that it was not until the 15th century in Florence, Italy, that the architect and engineer Filippo Brunelleschi (1377–1446) rediscovered the laws of linear perspective. Between 1415 and 1420, Brunelleschi studied how objects, people and landscapes appear to change when seen from a distance, and he worked out a mathematical approach that shows how objects, people, buildings and landscapes appear to diminish as their distance from the viewer grows

Drawing with linear perspective is not difficult, but it is useful to understand the theories behind it. Once you are familiar with the theories and method of perspective drawing, you will be able to apply it intuitively to your drawings.

The picture plane

The surface of your drawing (or any flat work of art) is called the picture plane. It is an imaginary plane and includes everything that appears to be on the surface of the drawing or painting. Objects in the foreground of your drawing are on the picture plane, and everything behind these will appear to diminish in size.

If objects are not far away or are particularly large, they will not look much smaller as they recede into the distance, but if they are far away, they will appear to shrink more. Objects also appear to be closer together as they recede.

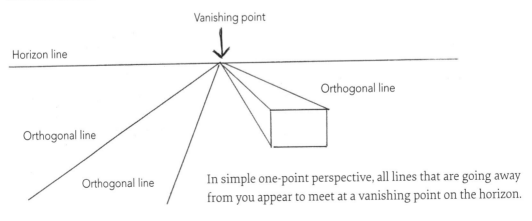

In simple one-point perspective, all lines that are going away from you appear to meet at a vanishing point on the horizon.

Perspective lines

In drawing, there are two main forms of linear perspective: one-point and two-point. Other forms of linear perspective can be used, including multiple-point, three-point, birds' eye and worm's eye views, but you only need to try these when you are more confident with drawing. To start drawing, concentrate on one-point and two-point only.

Linear perspective only affects receding lines – that is, lines that are going away from you, and not horizontal or vertical lines that are parallel to the picture plane. The following terms are useful for learning about perspective:

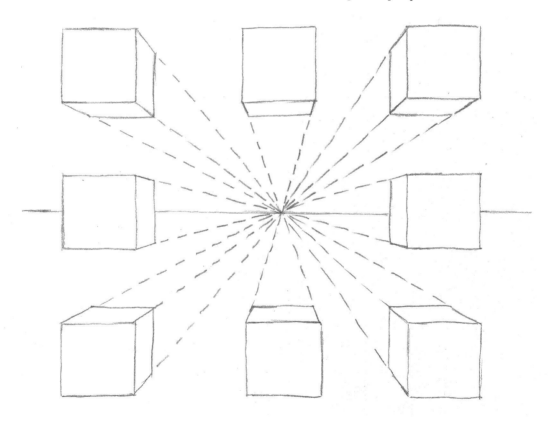

The boxes above are drawn in one-point perspective. Notice the vanishing point and how the receding lines change, depending on where the boxes are in relation to that. Also observe how the vertical and horizontal lines don't change.

- **Eye level** is the same as the **horizon**; that is, the line of your sight when you are looking at and drawing your subject matter.
- **The horizon** is the line where the sky appears to meet the land or sea.
- **Converging lines** are parallel lines that appear to merge as they recede into the distance. They are also called **orthogonal lines** or **orthogonals.**

The **vanishing point** is where the **orthogonals** appear to meet on the **horizon**. Some scenes will have many **vanishing points**, but to start, only draw one- or two-points.

The vanishing point is not always visible, for example, it may be through a wall or a mountain, but as you are learning the basics of perspective, it helps to make a light mark to indicate where it is in your drawing. You can erase this later.

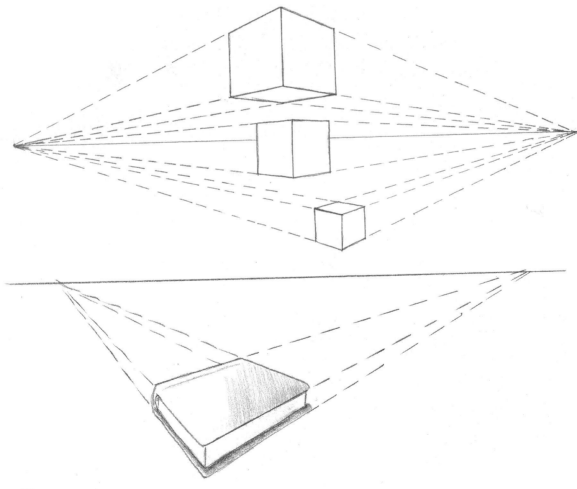

Practise perspective here:

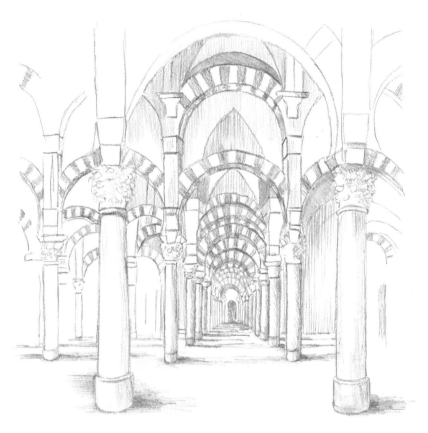

One-point perspective

One-point perspective is usually used when the subject is viewed from the front, such as when looking directly into a room, or when looking straight down a road or railway track. It is often drawn by architects, interior designers and illustrators. In this drawing of the Mosque of Cordoba, one-point perspective has been used to show how the arches and columns recede into the distance, meeting at a single vanishing point in the doorway at the centre.

Two-point perspective

Use two-point perspective when drawing something that is not facing you directly, but has a corner near to or facing you, or you are standing slightly to the side of your subject. Instead of one vanishing point, there are two, both at eye level, and usually at either side of your drawing. Often, these vanishing points will be beyond the edges of your drawing, but you must imagine where they are – or mark them if you have a larger sheet of paper or drawing board under your drawing.

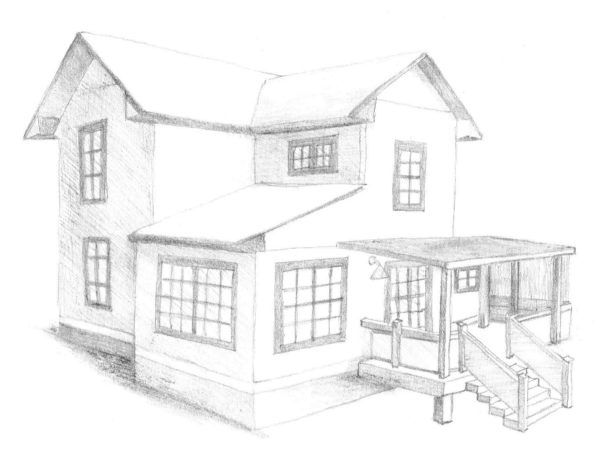

To create a two-point perspective drawing as shown here, establish your horizon line and two vanishing points. Place your vanishing points as far apart as possible on the horizon line. Next, draw the closest corner of the house as a vertical line. Connect the top and bottom ends of your vertical line to the left-hand vanishing point. End the side with a vertical line, remembering that all vertical lines in this drawing are parallel to each other. Repeat the same procedure for the other side of the house. Connect the remaining top corners to their appropriate vanishing points and erase any superfluous lines leading to the vanishing points.

Foreshortening

Foreshortening allows you to create the illusion of objects coming towards you. Imagine, for example, someone sitting in front of you, his or her legs crossed. The knees will appear to be disproportionately large compared to the rest of the body – simply because they are closer to you.

First studied during the 15th century by artists in northern Italy such as Andrea Mantegna (1431–1506), foreshortening is another optical illusion that conveys the idea of depth and distance in two-dimensional works of art. Objects that are close to us appear oversized in comparison with other elements and the distorted effect can help to create a sense of realism. As well as appearing to be far larger, these close-up objects and elements also look more compressed than objects behind them.

Foreshortened elements in a drawing could be, for example, a hand or foot reaching out to you; part of a building seen from a birds' eye view that is closer to you; a dog's nose sniffing you, a train hurtling towards you, and so on. In the first example, the hand or foot will look far larger and the arm or leg behind shorter than if they were in a relaxed, vertical position. In the buildings seen from above, the top of the tallest will appear larger as it is closer to you, and perspective lines will show that the lower buildings appear to become smaller as they recede. The dog's nose, as seen in the drawing here, will also appear larger and shorter than if the dog was drawn from the side.

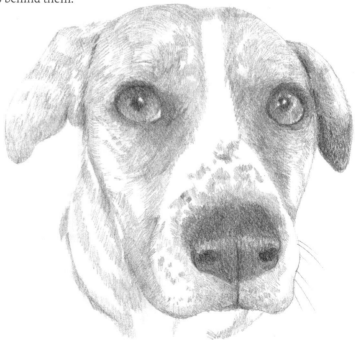

Drastic and distorted

As well as a three-dimensional effect, foreshortening often provides dramatic emphasis. When foreshortening occurs, forget everything you know about proportion! Just draw what you see, no matter how distorted it might seem. Even something as basic as a pointing finger in a clenched hand can take on a drastically different appearance. In this example, the pointing finger is shown straight-on, so that only the point of the finger is visible – it appears as a circular form, as you are viewing it from the tip.

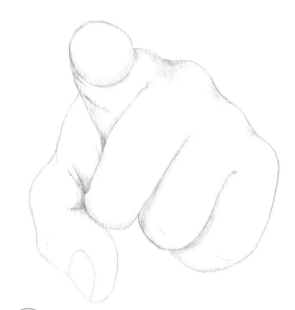

Practise foreshortening here:

Atmospheric perspective

In drawing and painting, depth and distance can also be expressed with atmospheric or aerial perspective. This is when objects or landscape elements in the distance appear less distinct and less brightly coloured. So foreground elements in a drawing should be sharper, with greater definition, details, tonal contrasts and, if you're using it, colour, while objects in the distance take on a blue-grey appearance.

Atmospheric perspective occurs when particles in the air (such as water vapour, dust, rain, pollution and other micro-particles) affect what is seen. Forms viewed from a distance are less defined and show less tonal contrast, because there are more particles in the atmosphere, between the forms and the viewer. Similarly, the wavelengths of colour are affected by distance. Strongly contrasting tonal contrasts and sharp details should be apparent in the foreground. Objects in the middle ground are slightly less defined than objects seen in close-up, and in the background, there should be little contrast between tones.

Leonardo da Vinci (1452–1519) first used the term aerial perspective and 'the perspective of disappearance' in his notebooks in the 15th and 16th centuries. He made his objects at the front of his paintings seem clear, in sharp focus, while those in the background were soft and blurred.

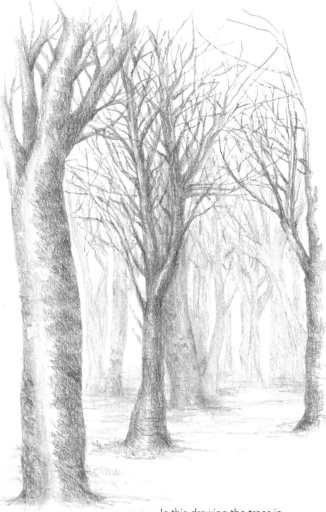

In this drawing the trees in the foreground are rendered with strong tonal contrasts and clear lines, while those in the background are lightly sketched, creating a sense of depth.

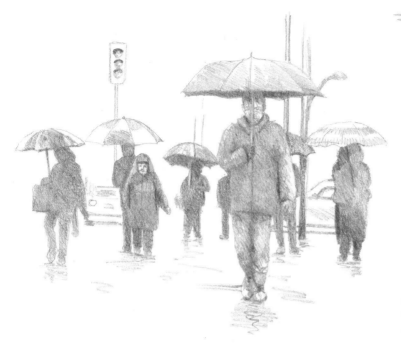

In this sketch the background figures are little more than silhouettes, while the figure at the front is shown in more detail. None of the figures is shown in sharp focus due to the rainy conditions that blur the view.

Practise aerial perspective here:

Composition

Composition is the arrangement of visual elements in an artwork. It gives an image structure and can help to convey a feeling or message. A good composition draws in the viewer's eye and leads it around the image. How you arrange objects, or how you crop or frame a scene, is something that you will learn through experience. You will find that some arrangements suit your style and subjects better than others.

Conveying effects and moods

A well-composed drawing can convey different effects and moods. Through the composition, you can make a drawing seem energetic, dramatic or calm, for instance.

Compositions can be symmetrical or asymmetrical, light and spacious, or full and busy.

Try to plan where the most important elements of your drawing will be placed before you begin, and consider how big or small to make things, what shapes to use and what to emphasize. Decide on the direction of light, how strong to make tonal contrasts, what details to include and where the main focus will be. This is not as complex as it might seem! Most of us know instinctively what pleases our eye.

Compositional arrangements

There are various tried and tested compositional arrangements, which include:

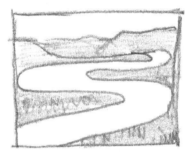

S-shaped

The objects in the drawing form a shape similar to the letter S, making the composition fluid and graceful. This works well for landscapes.

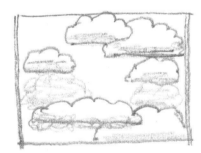

O-shaped

For this composition, draw objects and lines to form an O shape. This can work well with portraits and still-lifes or, as here, to add structure to a skyscape.

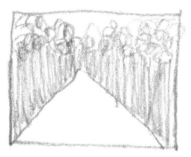

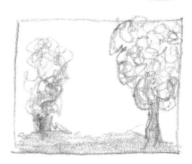

X-shaped

An X-shaped composition often features an example of one-point perspective.

U-shaped

With vertical elements on either side of the drawing and a horizontal line between them, forming the U, this can create a restful, balanced composition.

V-shaped / triangular

Angled or V-shaped compositions can convey a sense of dynamism or stability, depending on the position of the V-shape. For instance, an upside-down V-shape is stable, while a V on its side creates a sense of dynamism or movement. The V shape can be at any angle or position: horizontal, upside-down or in the conventional position of a V.

Triangular arrangements can be aesthetically pleasing, with their powerful sense of structure and stability. Arrange objects into a roughly triangular shape of any size, with the base of the triangle at the base of the drawing.

L-shaped

Place objects on one side of your drawing with an open area on the other side. Also include a horizontal base to form the L-shape. Your focal point can be either the elements at the side, or it could appear in the open space.

Rule of thirds

This is a way of placing the most important parts of an image at eye-catching places. The drawing is divided into nine equal parts by drawing two horizontal lines and two vertical lines within the overall frame. The focal points of the composition are placed around one of the four intersections of the lines.

Rule of odds

Odd numbers of objects in a composition appear more dynamic and natural than objects in even numbers. Even numbers can appear overly symmetrical and do not engage viewer's interest in the same way.

The Golden Ratio

In mathematics, the golden ratio is the ratio 1:1.618. It is produced by dividing a line in a particular way:

$$a \text{ / } b = (a + b) \text{ / } a = 1.618.$$

In art, a rectangle with sides that are in the golden ratio is often thought to be pleasing to the eye. You can divide the rectangle into successive golden ratios to produce a golden spiral. The Golden Ratio can be created with a rectangle drawn to a ratio of 1:1.618. Next, a line is drawn inside the rectangle to form a square. The remaining part of the rectangle then has the same ratio as the original rectangle.

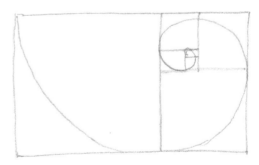

Practise your own thumbnail compositions here:

Creating an interesting composition

Every drawing should have a focal point, or point of interest. A focal point will give your artwork more interest and impact, guiding the viewer into and around the image. Sometimes, this can simply be a space amid busier elements, a highlight, an object, a figure or feature, or a particularly detailed area. The focal point is the part of your drawing that attracts more attention than the rest.

As well as focal points, there are other ways to create an interesting composition:

- **Overlap**. To make a scene or subject look real, layer elements of your drawing to add depth. Group objects together to do this.

- **Proportion**. Make sure that the sizes and dimensions of the elements in your composition make sense and allow enough space for them.

- **Balance**. Plan where you will place everything so that the drawing is balanced. This does not mean you need to make it symmetrical, but avoid it looking lopsided or overly heavy in any one area – unless you are intentionally juxtaposing mass with space.

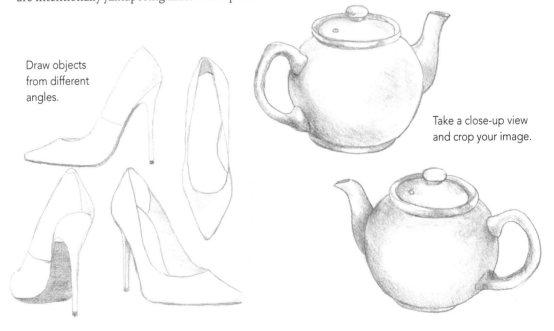

Draw objects from different angles.

Take a close-up view and crop your image.

- **Rhythm**. Similar to balance, consider the rhythm or repetition in your drawing. Repeating similar elements with different characteristics creates a rhythm that will draw the viewer's eye around the image.

- **Cropping**. Think about cropping some objects at the edges of drawings, as if you were taking a snapshot. This gives the image immediacy and can prompt the viewer to make up the rest of the cropped image in their mind's eye.

- **Viewpoints**. Unusual or unexpected viewpoints can be intriguing and can create different moods. Consider viewing your subject from above, from a worms' eye view or from the side – three entirely different viewpoints that can change the entire look of the work. [N.B. Close-up example removed here as covered in the next bullet point]

- **Close-ups**. Zooming into your subject matter (for example plants, vegetables, fruit, shells, marbles, toys, sweets or cakes, parts of the human body such as an eye or hand, or parts of an animal) can result in powerful drawings.

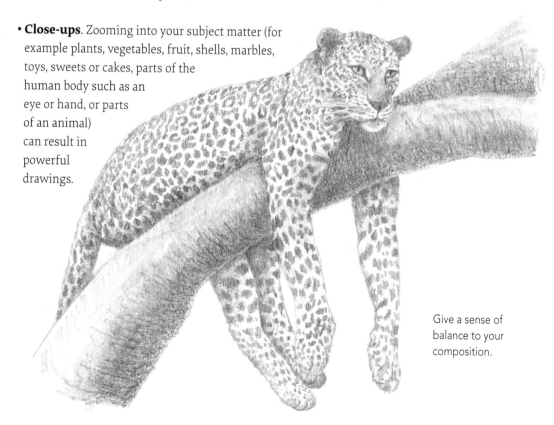

Give a sense of balance to your composition.

Subjects and Themes

The theme of your drawing is the overall idea or message you want to convey, and the subject is what it actually shows. They can be anything you like! Traditional themes include portraits, figures, landscapes (as well as seascapes and cityscapes) and still lifes. More unusual themes might include close-ups, patterns, inside-out, music, transparency or textures. Subjects might be the seaside, friends, a pet dog, your breakfast, a local woodland, a corner of your home. Your imagination is the only limit when it comes to choosing what and how to draw.

However, it is probably best to start with simple, straightforward themes and subjects, and slowly expand as you gain confidence. You will be amazed at what you can achieve once you feel confident in your own ability.

Still lifes can include anything that is inanimate. They are great when you are starting to draw as everything stays where you put it and every element can be moved and placed where you like. Still lifes work well when you group together similar or themed items, such as kitchen implements, fruit and vegetables, bottles and glasses, shells and stones, cakes, toys or shoes. You can choose objects that reflect your hobby, such as gardening, sewing, knitting, woodwork or swimming, or select other items that interest you, like jewellery, chocolates or art materials. Try to choose objects that complement each other and consider how you will visually link them so that they make a pleasing arrangement.

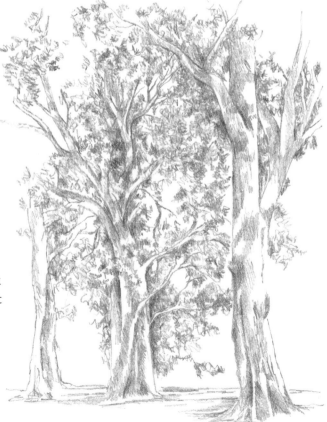

Landscapes From vast panoramas to small snapshots or aerial views, landscapes can vary hugely. They can include mountains, fields, buildings, rivers, beaches or the sea. You could draw your front garden or a corner of the local park; rooftops and sky; or a bluebell wood. Most landscapes consist of several smaller areas within one larger scene, but don't let this daunt you; take your time and focus on the negative shapes, squint your eyes to work out where the light and dark tonal values are and use various marks to convey the different textures within the scene.

Portraits, figures and other animals can be static or dynamic, simple or complex. A simple drawing of a portrait would be front on, or profile. A complex version might be a three-quarter view, the figure sitting or moving, or holding something. You can group figures together or draw them on their own, draw them from a distance or in close-up. As with all themes, only draw what you actually see, including negative shapes between and around limbs and features.

Style

Although this book focuses on drawing in a realistic style, there are many other drawing styles that can be studied and explored. Each style gives a different result and requires different skills. Some drawing styles are quite meticulous, requiring time and patience, while others can be produced with a more relaxed, looser and freer approach.

Everyone develops their own style after they have had some experience of drawing. Once you are comfortable with the techniques shown in this book, you might want to experiment and expand your skills. Exploring different styles, and even combining them, can give your usual approach a boost.

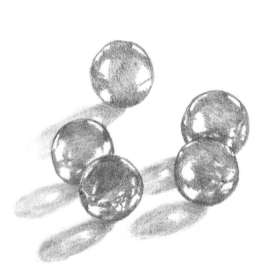

Positive possibilities

As you will have discovered in this book already, there are no hard and fast rules in drawing. The styles discussed on the following pages are only intended to show you some of the possibilities. Time spent trying out some of these approaches can only have a positive impact on your creativity.

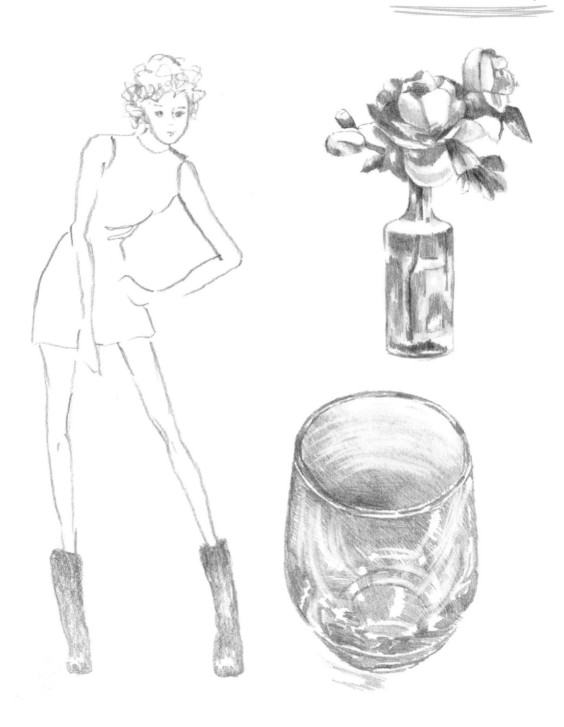

Contour drawing

A contour drawing is a drawing without any
details, texture or tone. It consists only of the
contours of the shapes and forms you are drawing.
It is a useful exercise when you are learning
to draw, as it focuses your mind entirely on
the shapes you are reproducing and the three-
dimensional contours – which are not always easy
to imagine or replicate on flat surfaces. Although
you are unlikely to use contour drawings as final,
complete images, they help to clear your mind
of all other aspects of drawing for a while and to
focus on creating form. When you return to more
customary styles of drawing, you will be more
mindful of three-dimensional forms.

While you ignore details in order to concentrate
on the prominent contours of your subject,
you can vary your lines, altering the character
of each mark to produce certain effects. For
example, a line can be lighter in value in some
places to suggest different heights of objects, or
the distance between objects in the drawing. A
darker part of the contour could represent part of
an object with little or no light falling on it.

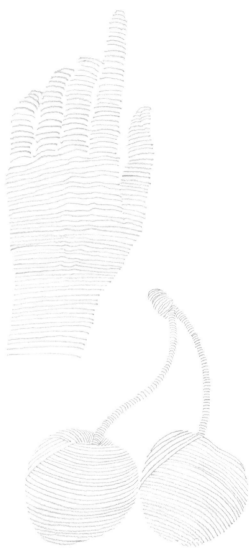

Method

Try drawing something simple to start with, such as a
piece of fruit or a hand. Hold your pencil, pen or charcoal to your paper and imagine
that you are drawing the forms of your subject. As you look at this subject, move
your eye slowly around the contours and move your pencil at the same time, in the
same shapes and directions. Take your time. Your eye will move faster than your
pencil, so slow down where you need to – this isn't a race. When you return to more
customary types and styles of drawing, this type of drawing will make you more
mindful of 3D forms.

Practise your own contour drawings here:

Continuous line

A continuous line drawing is just what it sounds like; a drawing made without lifting the pencil from the paper until you have finished. It is a helpful exercise for several reasons:

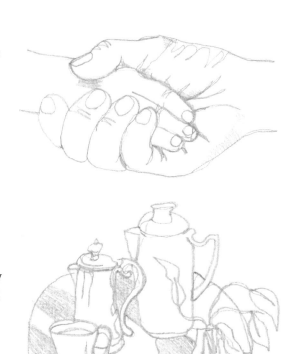

- To draw continuously you must let your line flow, which means no overthinking, no planning, no details! (As well as being a useful discipline for serious artists, this can be a fun exercise for children.)
- You will probably focus less on the subject matter and more on how you draw, concentrating on how you will represent every angle correctly and where to move your pencil or pen next. This helps you to develop better hand-to-eye coordination.
- As you focus on the process of drawing rather than the result, it can help you to become less concerned about making errors. As a result, you may achieve greater control and develop a looser, more confident drawing style.

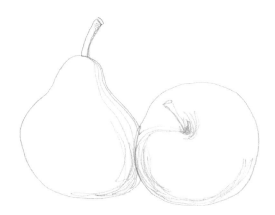

Method

To begin, place the tip of your drawing implement anywhere on your paper and simply start drawing. Keep your pencil or pen moving on the paper and don't lift it up. Travel around the outlines of your subject, then move inwards for some markings, including some tonal scribbles. The overall effect might look messy but that doesn't matter: you will feel the benefits when you return to more customary types of drawing.

Practise your own continuous line drawing here:

Gesture drawing

Gesture drawing is a loose form of drawing that captures basic forms and expresses movement. It can be used for any subject and it must be produced quickly. By creating gesture drawings, you will loosen up for when you produce more detailed drawings.

A fairly free method, gesture drawing requires you to hold your drawing implement quite loosely and to work with broken marks rather than solid. It's useful for making rough sketches and is focused on the energy of your subject, rather than on producing tight, lifelike images – although you should aim to create something recognizable. It is especially effective for representing the mood of something you glimpse in passing, or for capturing moving people or animals.

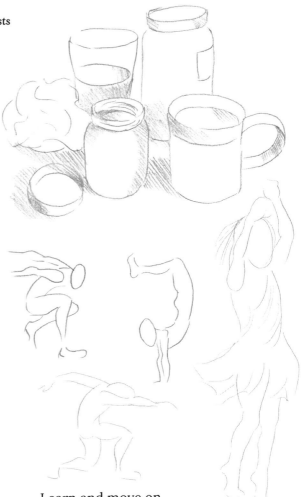

Method

To begin making gesture drawings, try to recreate a sense of the total form and energy of your subject. Look at your subject and try to depict it with a few abridged marks. Your marks should be fast and fluid, capturing a general feeling rather than close details. Look at your subject and try to depict it with a few abridged marks. You can vary the types of marks you make as you express the essence of your subject as well as the energy and feelings you are aiming to portray. Be aware of the action, form and pose of your subject, and also the negative shapes around it.

Learn and move on

Don't worry about making mistakes; you shouldn't be erasing anything. If you make a mistake, simply learn from it, leave it there and move on to the next part of the drawing, or start a new one. The more problems you encounter, the more solutions you will develop, and you will learn how to cope with or avoid these mistakes in the future and to draw more instinctively. However, working quickly does not mean working recklessly; it means learning to make quick decisions as you draw, and being prepared to change your initial intentions.

Practise your own gesture drawings here:

Sumi-e

Japanese ink painting, or sumi-e, is a pared down form of drawing using just black ink and white space. 'Sumi' means *black ink* and 'e' means painting.

Zen Buddhist monks from China introduced this style of ink art to Japan in the 14th century. Over time, the brush strokes were reduced and simplified in style and often combined with poetry. Sumi-e is produced with certain types of brushes and thin, durable Japanese papers, often produced from a type of mulberry.

Method

Sumi-e can take years to study and learn but you can create drawings that recall sumi-e, working with pen and ink, or even pencil or charcoal. Reduce your elements and details; think about the white space of your paper as much as the marks you make; create flowing, asymmetrical compositions with pared-down imagery and minimal marks. Use a range of tones, from deepest black to palest grey, and draw your subjects from nature.

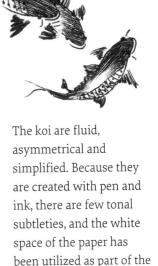

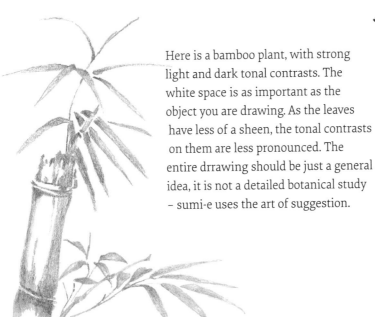

Here is a bamboo plant, with strong light and dark tonal contrasts. The white space is as important as the object you are drawing. As the leaves have less of a sheen, the tonal contrasts on them are less pronounced. The entire drrawing should be just a general idea, it is not a detailed botanical study – sumi-e uses the art of suggestion.

The koi are fluid, asymmetrical and simplified. Because they are created with pen and ink, there are few tonal subtleties, and the white space of the paper has been utilized as part of the overall image.

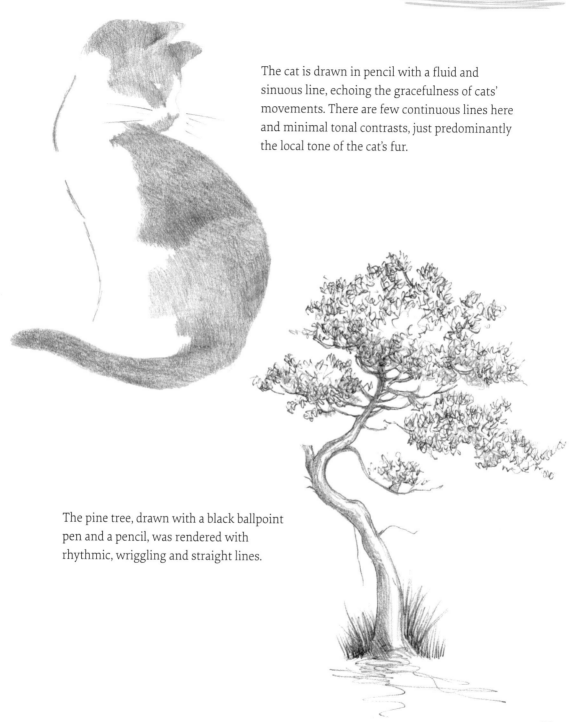

The cat is drawn in pencil with a fluid and sinuous line, echoing the gracefulness of cats' movements. There are few continuous lines here and minimal tonal contrasts, just predominantly the local tone of the cat's fur.

The pine tree, drawn with a black ballpoint pen and a pencil, was rendered with rhythmic, wriggling and straight lines.

Projects

The drawings on the following pages are shown in steps, from the first to the final marks. These stages will help to guide you through different subjects and aspects of drawing. If you take your time and work carefully, you will see how easy it is to begin with a few simple shapes and build them into a convincing image. By gradually adding or altering marks, you will reach the point where you can add textures and tones, working towards a final drawing that you are pleased with.

Different starting points

The following projects include a variety of subjects, ranging from natural objects in a still life, to a landscape, a cityscape, a figure and a cat. The stages of drawing sometimes differ, to show you alternative ways of going about them. For instance, the figure of a little boy kicking a football on pages 110–13 begins with a stick person that is then fleshed out. The still life on pages 74–7 begins with simple shapes (circles, ovals and curved lines) that all come together to show a bowl of fruit.

Some of the projects are less detailed than others, but the more detailed drawings are not necessarily more difficult; they simply require extra time and patience. Each project offers you a chance to practise and improve your skills. They each build on aspects of drawing already discussed in the book.

By following the projects here, you will see that drawing is quite a simple process and good standards can be achieved in a short time. Once you have worked through a project, you can use the same process for anything else you choose to draw. And if you draw regularly, you will find that it becomes easier as you improve.

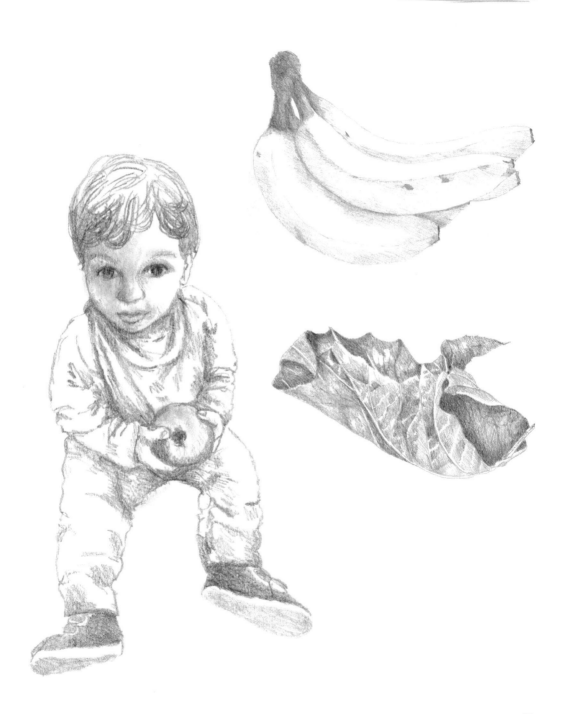

The natural world

Nature as a theme has been prevalent in art since the earliest drawings, paintings, sculptures, reliefs and prints were made by artists tens of thousands of years ago. Right up to the present day, nature has probably been explored by more artists than any other theme. Its representation has been both realistic and abstract, and either detailed and intricate or fluid and free. From the landscapes of John Constable, J.M.W. Turner, the French Impressionists and the painters of the Hudson River School to Islamic patterns, Indian miniatures, Japanese woodblock prints and the sinuous, flowing natural forms of Art Nouveau, nature has formed the basis of art in so many cultures.

With an almost endless choice of subjects, the natural world can be the main focus of all your drawings or it can form just part of them. Subjects from the natural world can be as small as a tiny shell or a flower, or as large as an entire landscape. They can be a simple as a banana or as complex as a forest. Nature can also be used in drawings to suggest underlying meanings or feelings. Think of a stormy sky, a calm sea or a bowl of abundant, ripe fruit. Aristotle once wrote: 'Art not only imitates nature; it also completes its deficiencies.' So feel free to adjust what you are drawing to convey a particular feel or mood.

The following projects focus on natural themes and subjects, from two still lifes showing fruit and vegetables, to some unfurling roses, a scene filled with winter trees and a wide landscape. Have a go at them, following the steps and instructions carefully. You can practise both in the pages of this book and using your own paper or sketchbook. These projects can be just the start of your drawing journey. Use the skills you develop to draw many other images of the natural world – there's plenty of scope!

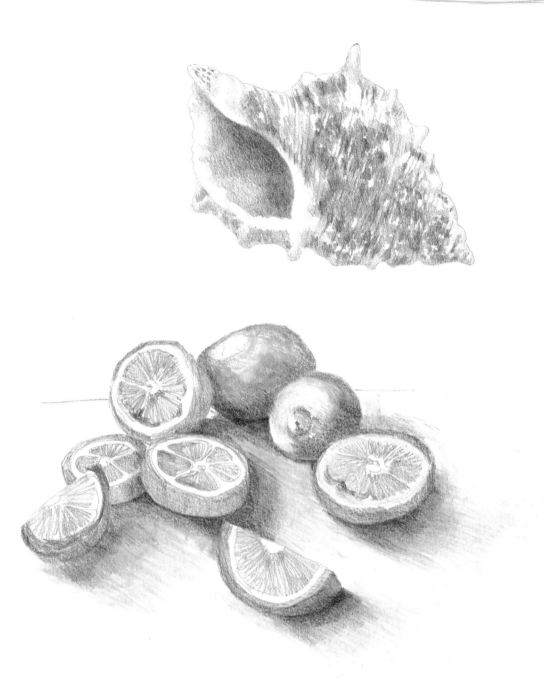

Fruit bowl still life

This still life of fruit in a bowl is made up predominantly of curved lines, ovals and circles. Nothing really breaks up the calm curves; there are no tricky details or shapes to worry about.

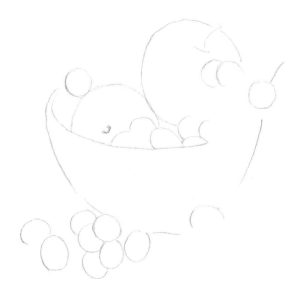

1. *Begin by marking down some of the curving shapes, paying attention to the negative spaces between them.*

2. *Start to form the actual shapes of the individual pieces of fruit and finish some of the outlines of the grapes using smooth, confident arcs. Squint your eyes to see where the darkest areas of the arrangement occur and roughly mark these in.*

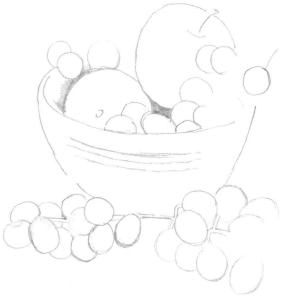

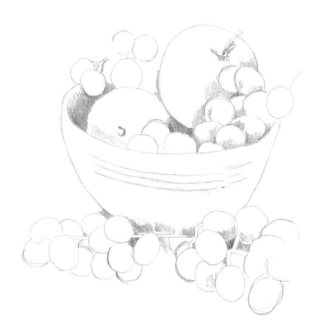

3. Using soft, layered marks, build up some of the shadowed areas on and around the pieces of fruit. Soft pencils such as B, 2B and 3B work well for this.

4. Continue shading, squinting your eyes so you can identify the areas of light and dark. Add some light details such as stalks and more grapes.

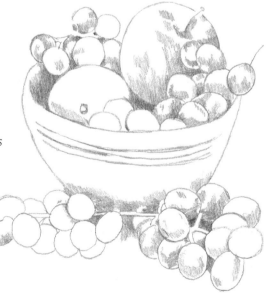

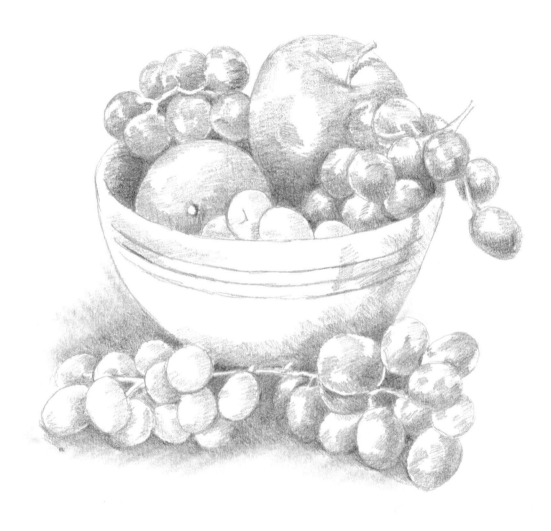

5. *Once you are confident that your shapes are correctly placed and shaded, carry on finishing off details with both tonal and textural marks. Keep your shading light; you can always add further layers if you want a deeper, stronger image.*

Try drawing your own version of a bowl of fruit here:

Trees

Trees vary immensely in appearance, both between different species and – for deciduous trees – according to the changing seasons. They present endless opportunities for drawing.

When looking at any tree you intend to draw, examine its basic shapes: the width and height of its trunk; and the width, height and shapes of its branches and leaves. Once you have observed those general aspects, notice the overall structure of the tree and the directions in which the trunk, branches and leaves grow. If you are drawing a group of trees as in this example, you also need to consider how the trees are placed in relation to each other and where their branches cross. When you draw trees, don't try to draw every leaf, twig or detail of the bark.

1. *Look for the widths and heights of the tree trunks. Those further away will appear narrower than those in the foreground. You are only drawing the overall appearance, not exact details, so also look for the negative spaces – the gaps between the trees. Begin by marking on some vertical lines to place these trees. You can also lightly mark on the curve of the stream.*

2. *Draw more vertical lines to introduce the slender trunks of the silver birch trees. Add some angled lines as you start to place some of the branches. You can begin to add some shading at the base of some of your trunks.*

3. *Continue adding vertical lines for tree trunks and angled lines for branches.*

4. *Build up darker tones at the base of the tree trunks and follow these into the edges of the stream where the light doesn't fall. Also begin to make small scribbled lines on some of the tree trunks; these are the natural markings on the silver birch trees.*

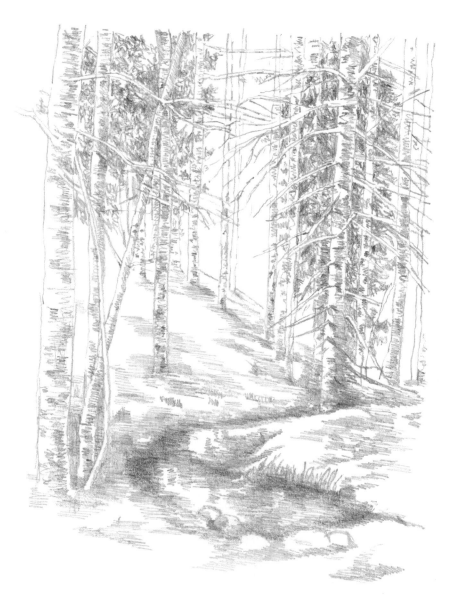

5. *Work across your drawing, adding scribbled horizontal lines on the trunks, leaving the branches white. The branches should be particularly narrow and delicate. Shade the darkest areas around the edges of the stream with a soft pencil, such as a 3B or 4B. More dark scribbled marks go behind the tree trunks in some areas to suggest evergreen trees in the distance.*

Try drawing trees as often as you can. Keep a sketchbook with you and follow the same process as you have here.

Try drawing your own trees here:

Roses

Rose petals, and parts of several other flowers and objects in nature – including lilies, daisies, buttercups, sunflowers, pine cones, honeycombs and snail shells – all follow a 'Fibonacci' pattern that roughly equates to a spiral. Known as the Fibonacci sequence or numbers, the seeds, petals, pistils, leaves and veins of the rose are all formed using a mathematical formula. This pattern is worth looking out for as you draw this overhead view of three roses. Two are cut off at the edges, giving the drawing a sense of immediacy, like a photograph. There are no other elements in this drawing: no leaves, stems, trellis or pot – just the flowerheads themselves.

1. *Mark in some of the curves, spirals and circles to position the roses on your paper and in relation to each other.*

2. *Start to form the shapes of the petals; they curve and undulate around the spiral shape. As you draw them, erase some of your earlier planning marks. Note that the petal undulations are smaller and the curves tighter towards the centre of each flower.*

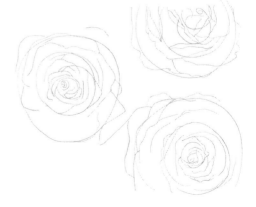

3. Continue adding petal shapes and refining them. Use a fairly soft pencil such as a B or 2B and don't press too hard, in case you need to make any adjustments. Once you have drawn all of the petals, erase the rest of your planning marks.

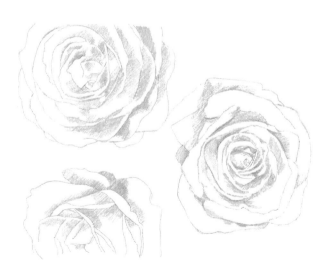

4. Still using a soft pencil (or two soft pencils, such as a B and 3B or 4B) add shading between the petals where the light doesn't fall. Some petals will be slightly darker than others because of the fall of light. To see where the darker tonal areas are, squint your eyes as described on page 29. However, ensure that you leave plenty of white space for highlights – this will help to retain the sense of delicacy.

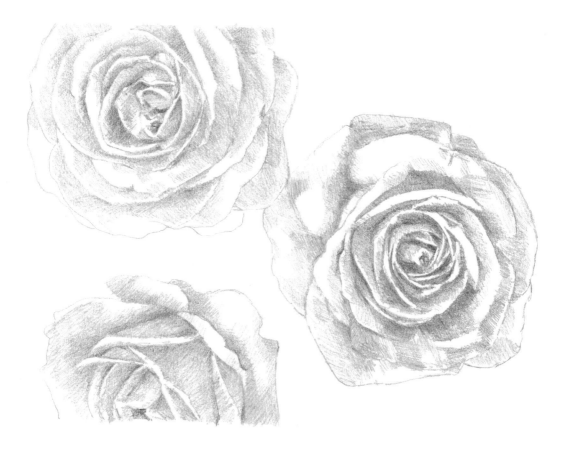

5. Continue to build up the shading, layering in the areas where the tones are darker. For smooth, soft shading, hold your pencil lightly and let it glide over the paper. Work across the drawing, balancing, building and adjusting your tonal marks until you are happy with your drawing.

Try drawing your own version of a rose or roses here:

Kitchen still life

Tomatoes, mushrooms, a pepper grinder, a jug and a bottle – the items in this still life could be found in any kitchen. The arrangement is quite straightforward, mainly comprising curved lines and circles. The objects are close together, so there are few gaps between them.

1. *Begin by marking on some of the curved lines and circular shapes closest to you. Use a soft pencil, such as a 2B, B or HB, and press lightly. Assess the heights and widths of the objects in the arrangement, either by eye or using the sighting method (see pages 22–3).*

2. *Continue marking down the shapes that are in front of you, using fine, light outlines. Compare the dimensions of the various elements in your composition. For instance, compare the mushrooms to the tomatoes; the heights of the taller, man-made objects; and the sizes of the negative shapes between them.*

3. *Start to refine the shapes of the objects in the group. The tomatoes are slightly squashed circles, as are the mushroom tops and the top of the pepper grinder. There are some straight lines in the man-made objects: the bottle sides and top; the top of the jug; and the small part of the chopping board seen beneath the tomatoes and mushrooms.*

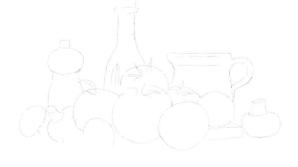

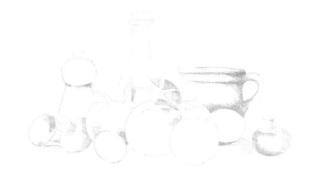

4. Once you are confident with your outline shapes, squint or half-close your eyes to see the different tonal values and gradually begin to add some shading. Work across your drawing to keep your tones even and build up from soft shading to deeper, using layering rather than heavy pressure.

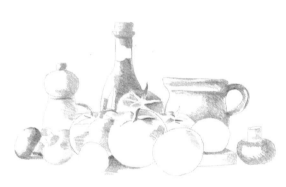

5. All of the objects in the arrangement have smooth surfaces so your shading should also be as smooth as possible. Use a softer pencil for deeper tones, such as under the tomato leaves and on the bottle. There are also some dark shadows beneath the objects. Start to mark on these shadows – not too heavily, but enough to anchor the objects to the table surface. If you don't include these cast shadows, your objects could look as if they are floating.

6. Work across the drawing, building up layers of tone, but being careful to leave plenty of white space to suggest light. As you half-close your eyes, you will see that there are a few small areas that are especially dark.

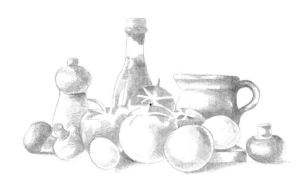

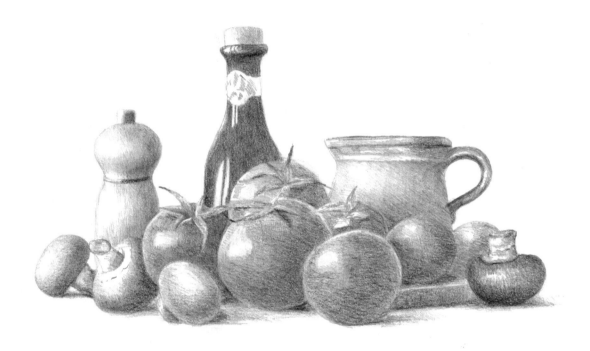

7. At this point, you may wish to leave your drawing if you are happy with it, or continue to add some shading and detail. A range of pencils have been used here to give deeper, darker tones in certain areas and achieve a highly worked result.

Try drawing your own kitchen still life here:

Landscape

Even more varied than trees, landscapes can be open and spacious, or more closed in, perhaps packed with vegetation or rocks. They can feature mountains, hills, forests, water or other elements. Whichever type of landscape you choose to draw, the process will remain the same as that shown here.

Durdle Door is a natural limestone arch on the Jurassic Coast in Dorset, southern England. It has been a popular subject with artists for centuries. The rocks contrast with the sea and grasses, while the dramatic arch juts out over the sea.

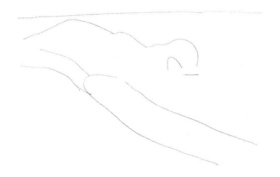

1. *Mark the position of your horizon line. One-third down from the top of your paper will give a natural, comfortable composition (see page 54). Lightly mark on Durdle Door itself and the shape of the promontory joining it to the cliff. Make sweeping lines to denote the base of the cliff and the water's edge.*

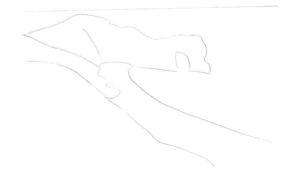

2. *Continue building the outline of the main elements in the landscape. Don't worry about details at this point; you are just marking on the main structures.*

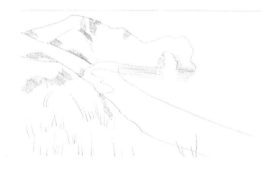

3. *When viewing a whole landscape, you will usually see only areas of tone rather than details. However, if you add more detail in the foreground of your drawing this will contribute to a sense of depth (see atmospheric perspective on page 50). Here, start to add detail in the foreground by drawing some tufts of grass, and indicate faintly the tonal areas of the cliffs beyond.*

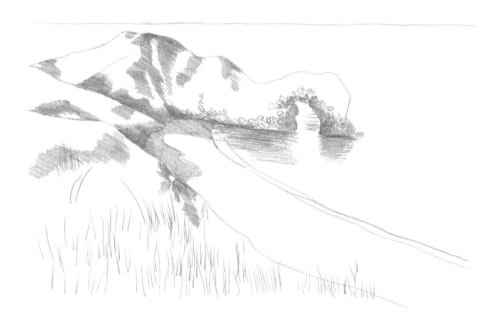

4. *Continue to work across your drawing, maintaining a balance of tones and details. Build up some soft shading on the rocks as well as shadows below the distant rocks, and the reflections of Durdle Door in the sea. Add more blades of grass in the foreground, holding your pencil at the base and flicking up and away.*

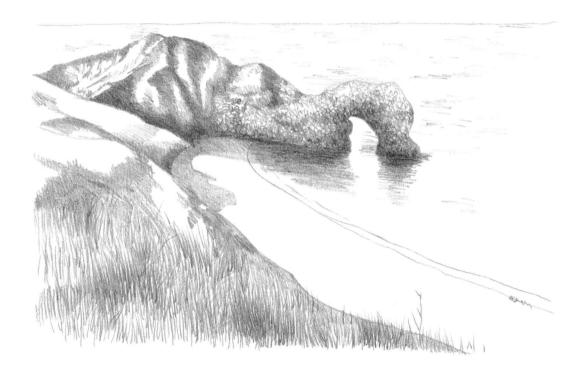

5. *To finish the landscape, continue adding tones, using a softer pencil for darker tones. Add some scribbled lines to create a sense of the rock textures in the distance and build up a dense foreground area of long grass, varying the tones within it. Soften the reflections under Durdle Door and add a few light, broken lines in the sea to suggest rippling waves.*

Once you have finished this drawing, you can follow the same process for any type of landscape you choose to draw. Make the general, basic outline first, then squint your eyes to see where the darker tones lie. Mark them on and work over your whole drawing to maintain balance, adding tones, textures and details – particularly in the foreground.

Try your own landscape drawing here:

The Manmade World

Much of our environment is manmade. Even a country landscape frequently features something built by humans, such as a house, a bridge or a fence. The main difference between drawing natural and man-made subjects is that the latter are often more rigid and precise. In this section, there are three projects that focus on man-made objects, including a still life, a room with furniture and a cityscape. Notice that the examples shown here – the wine glass, carriage clock and cutlery – have strong tonal contrasts. This is because they are made of smooth, shiny materials that catch hard reflections. Other manmade objects and surfaces have softer, less dramatic tonal contrasts. Think of woven or knitted fabrics, such as a sofa or a coat, or even a thatched roof. You can also find varied textures close to each other, such as paving against a metal lamppost, or a brick building with glass windows.

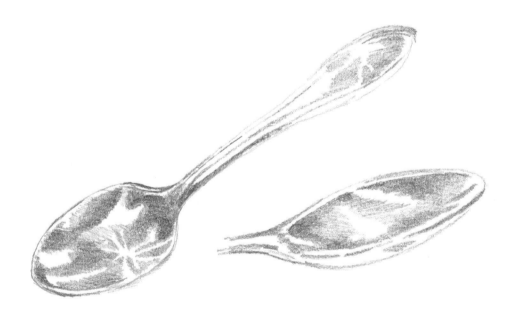

As you develop your skills, you might prefer to draw only manmade objects, as they are easily observed all around us, for example, pens, cups, furniture, clothing or buildings. Or you might draw a combination of natural and man-made objects, such as a house surrounded by a garden, a still life of vegetables and saucepans and other utensils, or a person sitting on a seat. Whatever you choose, the method is always the same: look for the structure, the basic shapes, the negative spaces and proportions. Once you have marked these down lightly, check to make sure everything looks correct and then go about adding tonal contrasts and a sense of texture. Keep observing the textures and feel of whatever you are drawing and where the light is falling. Perhaps there are several light sources; the light might be strong or subdued; you might be close to what you are drawing, or at a distance. Have a go at these next projects and see how you get on!

Teapot and cup

This simple arrangement of a teapot and cup consists of circles, ellipses and curved lines; there are no straight lines. Before you even begin to draw, look carefully at the two objects and assess the spaces between and around them. Check and recheck the distances between the various shapes and forms.

1. *As explained on pages 22–3, use the sighting method to measure what you see. Close one eye and hold your pencil out at arm's length. Draw rough, simplified shapes of the objects.*

2. *Continue measuring with your pencil and keep one eye closed as you check relative proportions. Using the first basic shapes you have marked down to guide you, begin to draw more accurate forms.*

3. Continue carefully drawing the shapes of the two objects, noticing their relationship to each other, their heights, the angles between them and the shapes and spaces around them.

4. Once you have established accurate outlines of the objects, begin to build up tonal marks. Both teapot and cup are made of china and their surfaces are smooth and shiny, so keep your marks smooth. Work across the drawing: don't spend too much time on any one area, but keep moving and adding darker tones where you see them. If you focus for too long on one area, you may over-emphasize that part of the drawing, which will create an imbalance overall.

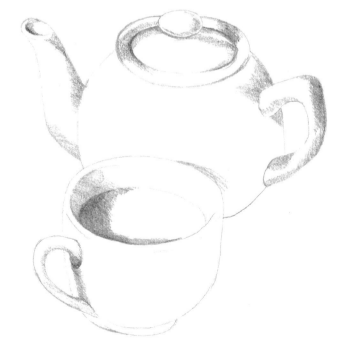

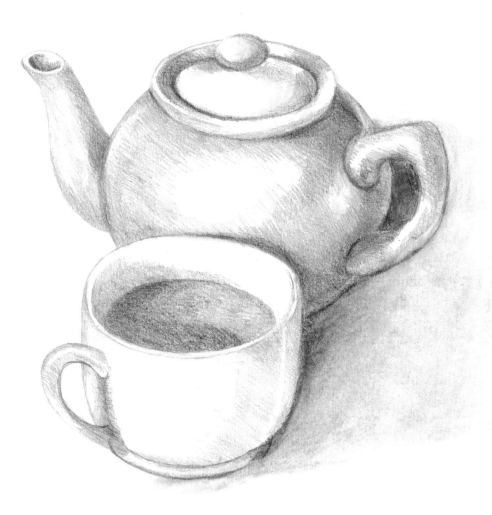

5. *The next stage requires patience! Simply build up shading using smooth marks. You can work in hatched lines, circles or whichever marks you feel comfortable with, but you should aim to make them as smooth as possible. Use softer pencils such as 4B for darker shadows and slightly harder pencils, such as a B or 2B, for lighter tones. Leave plenty of white space to show where the light falls.*

Practise drawing your own teapot and cup here:

Interior

Drawing rooms is a skill practised by many interior designers, and they are an interesting subject for anyone. If it's raining outside but you want to draw something larger than a still life, or if you want to practise perspective – an interior scene is the answer. This will more than likely be in your home, but it could also be in a café, a library, or other interior space. Find a comfortable place to sit, with a selection of pencils, paper or a sketchbook and a soft eraser, and a view of the room that you would like draw.

1. *Sitting up straight in your chair, use the sighting method described on pages 22–3 to start measuring the salient points and angles, including any corners, windows, ceiling and floor. Mark these down carefully, and gradually add more lines until you have the basic structure of the part of the room you are drawing.*

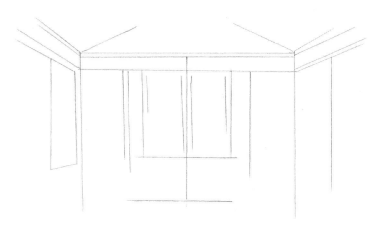

2. *Once you have marked down the main structure of the room, start adding details. You may need to erase some of your previous lines if there are objects in front of them, such as the lamps and table in this example.*

3. Using a fairly sharp pencil – either a B or an HB – continue drawing the furniture, windows and other details. Take your time and follow the rules of perspective (see pages 46–51). Don't press too hard: your lines should be clear and sharp, but you don't want to leave any indentations if you need to erase them.

4. Carry on drawing what you see: vertical, horizontal and oblique lines; curves and other shapes. You don't need to include every detail. As long as your perspective lines are accurate, your drawing will be convincing. You can crop the image wherever it suits you.

5. Using a softer pencil, such as a 2B or 3B, work across the drawing. Concentrate on adding tonal values
wherever the light doesn't fall. This is a light room, with diffuse light entering through the many
windows, so the darkest areas are underneath objects. The sense of being in a conservatory is created by
the scribbled lines at the windows, suggesting plants and trees outside.

Try drawing an item in this room (such as one of the lamps, windows or footstool) or the whole room here:

Cityscape

Cityscapes can be depicted from an unusual angle for dramatic effect, or show a more familiar skyline for a calmer feel. You can draw them from the central viewpoint, so that the buildings are on either side in a dramatic one-point perspective scene, or you can draw the buildings from alongside, with a viewpoint opposite them. Cityscapes can show what you actually see before you, or you can make up your own view, including some buildings that are there and others that are not. Do not include every window or door, as a more general view can be more impactful. Draw what you see using general, not exact marks.

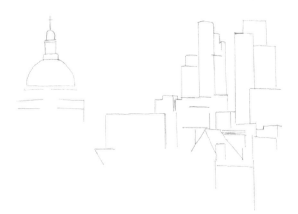

1. Form the main outlines of the buildings, judging their relative heights and sizes as you go. Use mainly vertical and horizontal lines, with some diagonal rooftops and one large curved dome to the left-hand side. The variety of the buildings' shapes, positions and angles creates interest.

2. Build up more of the buildings' outlines. Don't worry too much at this point about depth and perspective in your cityscape; just use a well-sharpened pencil with a light touch so that you can erase if necessary.

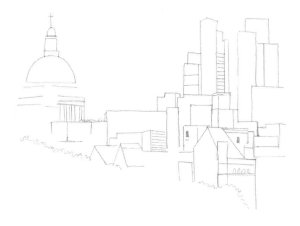

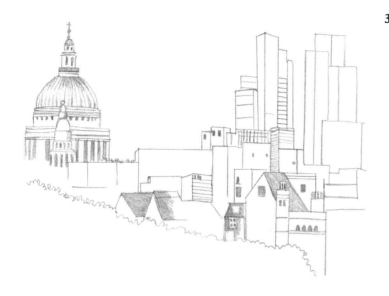

3. *Now begin to add some detail. This will be a general, overall view with few actual details, but there are ways of making the scene look as if it has depth. Start to add in some effects of light with darker, shadowed areas, and mark on a few windows and other features. This cityscape has a covering of greenery at the bottom of the drawing.*

4. *Continue to add detail and shading across the scene, but remember not to focus too much on any one area: the entire image is a general overview of a distant cityscape rather than a detailed exploration.*

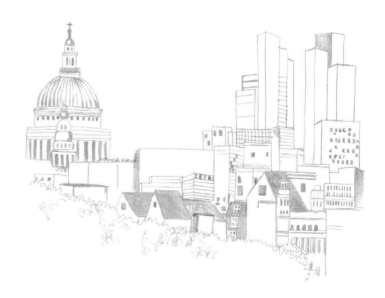

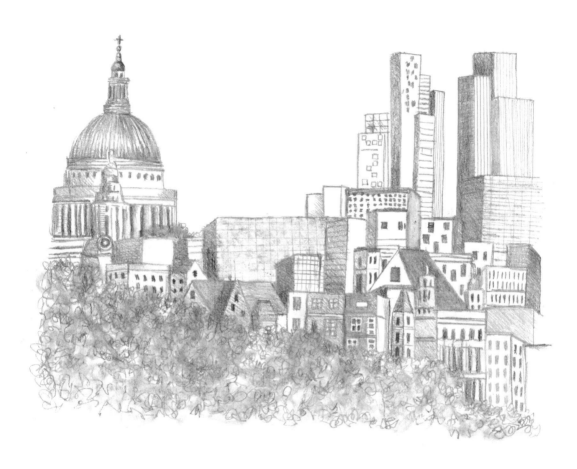

5. *Work across the scene adding angles, shading, windows and other details. Use rectangles and squares to mimic the windows. As you work, if necessary, revise and alter elemnts of your drawing. Be aware of where the light is falling and where it isn't. The greenery in the foreground is shown with scribbly marks that set it apart from the buildings behind. This city – based on London – like many cities around the world, features old and newer buildings, with very different architectural styles.*

Try drawing your own version of a cityscape here:

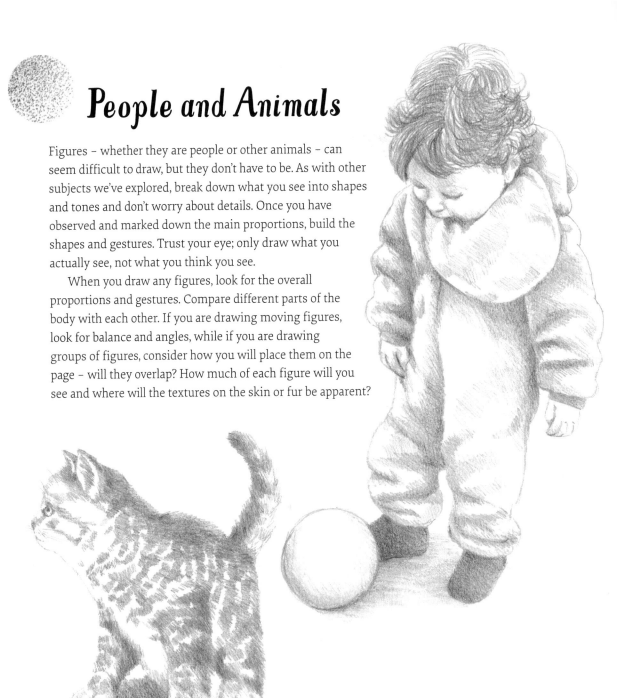

People and Animals

Figures – whether they are people or other animals – can seem difficult to draw, but they don't have to be. As with other subjects we've explored, break down what you see into shapes and tones and don't worry about details. Once you have observed and marked down the main proportions, build the shapes and gestures. Trust your eye; only draw what you actually see, not what you think you see.

When you draw any figures, look for the overall proportions and gestures. Compare different parts of the body with each other. If you are drawing moving figures, look for balance and angles, while if you are drawing groups of figures, consider how you will place them on the page – will they overlap? How much of each figure will you see and where will the textures on the skin or fur be apparent?

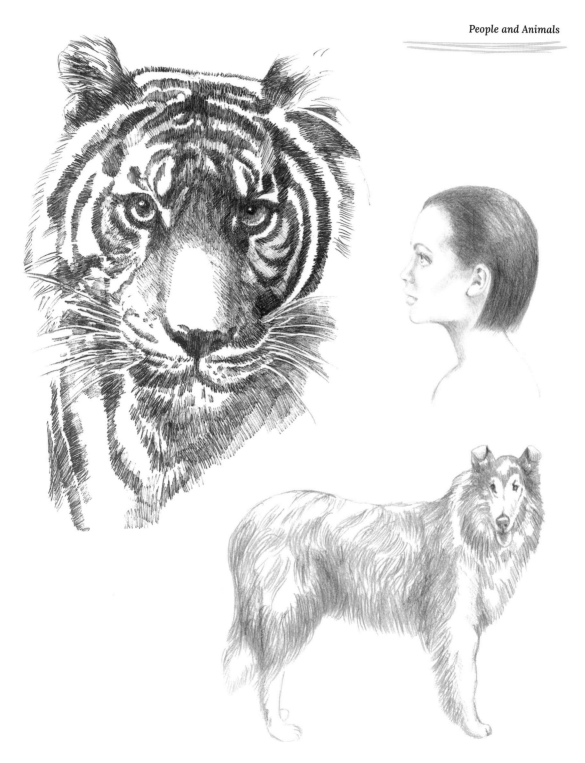

Figure in action

In this drawing of a little boy playing football, there is plenty of action and minimal detail. Use a sharp pencil to begin with and either keep the same pencil throughout, or move on to a softer pencil for shading.

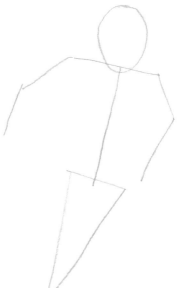

1. *Draw a stick figure; mark on the shoulders, hips, legs, arms and head. This is only a rough guide, but be aware of the approximate proportions of the figure.*

2. *Build up a simple outline of the figure. Note that the boy's neck is not visible as he is looking down. Draw a circle for a ball at his feet.*

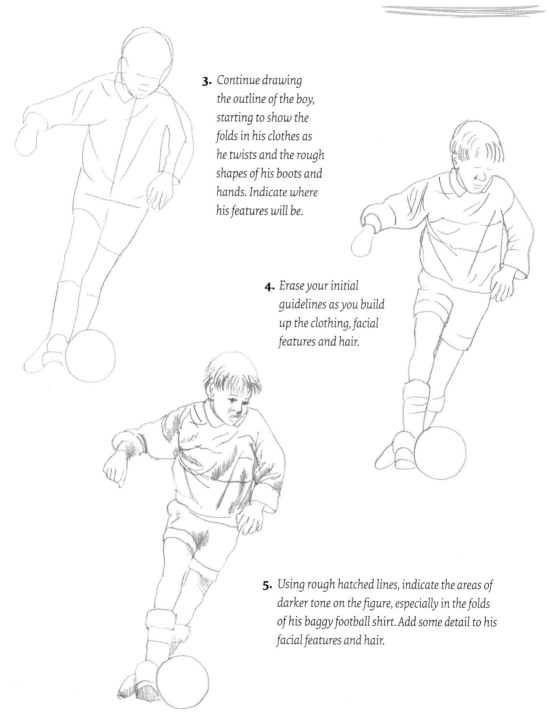

3. Continue drawing the outline of the boy, starting to show the folds in his clothes as he twists and the rough shapes of his boots and hands. Indicate where his features will be.

4. Erase your initial guidelines as you build up the clothing, facial features and hair.

5. Using rough hatched lines, indicate the areas of darker tone on the figure, especially in the folds of his baggy football shirt. Add some detail to his facial features and hair.

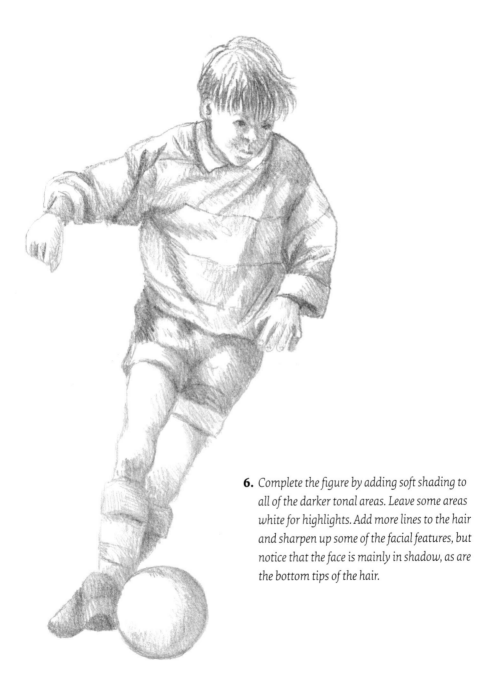

6. *Complete the figure by adding soft shading to all of the darker tonal areas. Leave some areas white for highlights. Add more lines to the hair and sharpen up some of the facial features, but notice that the face is mainly in shadow, as are the bottom tips of the hair.*

Practise drawing your own version of the little boy here:

Cat washing its paw

It's never easy drawing your pet! Animals just won't stay still long enough for you to capture those details on paper. Make quick sketches to help: as soon as you see a pose you want to draw, grab a pencil and jot down the main lines you see. These might be an outline, a spine line – where it arcs or twists – or other features; just a few marks to help you recall the pose. Be prepared to have several goes at this, as you become familiar with the method of making shorthand visual notes and using them as the basis of a drawing.

1. *Two almost circular shapes comprise the head and the main part of the torso. Notice how much smaller the head is than the body. Join them with a spine line, and lines to indicate the paws. Add triangular shapes for the ears.*

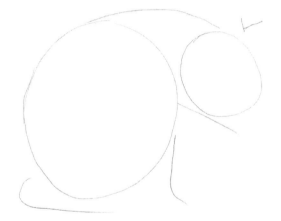

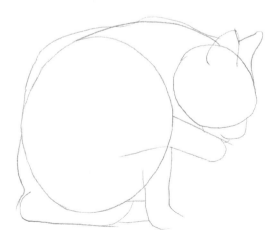

2. *Join up the shapes to build the cat's outline, including the ears, raised front paw, other front paw on the ground and a rough indication of the back legs on the ground. Make sure that the spine looks right – cats' bodies curve sinuously.*

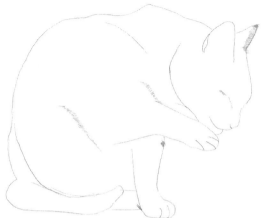

3. Erase your initial guidelines as you make the lines and shapes look more realistic and cat-like. Mark on the one visible eye and begin to add some lines to represent fur.

4. With a sharp point on your pencil, gently and carefully build up the cat's tabby markings. Use short scribbled lines to suggest short fur, drawing them in the direction the fur grows.

5. Carry on building the fur marks using a couple of sharpened pencils, such as a B and a 3B, or a 2B and 4B. Keep moving across the drawing as you work – the image could become imbalanced if you focus too much on any one area.

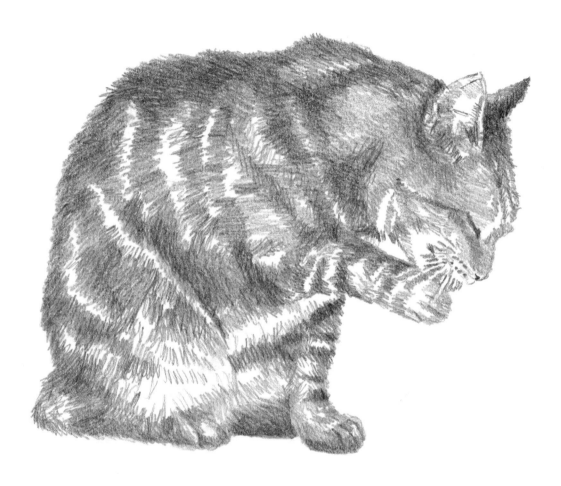

6. *The fur lines can be added rapidly. Don't deliberate over them, but in lighter areas such as around the ear, use soft pressure, so no marks end up looking overdone. Once the markings look realistic and the cat three-dimensional, use a soft, sharp-pointed pencil (such as a 3B, 4B or 5B) to mark the eye, nostril, back of the ear, between the paws and whisker area, with small dark lines and dots.*

Practise drawing cat markings, features and fur here:

Lion roaring

This drawing is particularly satisfying to make, capturing the lion's features, expression and the texture of its fur. By making your marks in the direction in which the fur grows and working fairly quickly, without labouring the image, you will also capture a sense of life and movement.

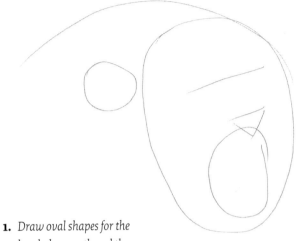

1. *Draw oval shapes for the head, the mouth and the ear, a triangle for the nose and a line to position the eyes.*

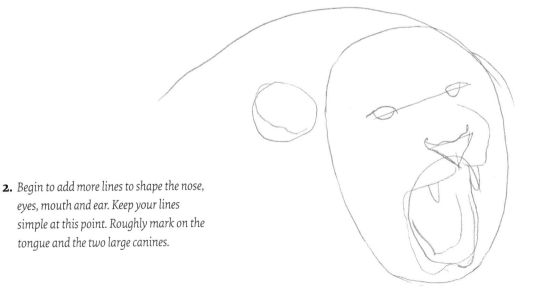

2. *Begin to add more lines to shape the nose, eyes, mouth and ear. Keep your lines simple at this point. Roughly mark on the tongue and the two large canines.*

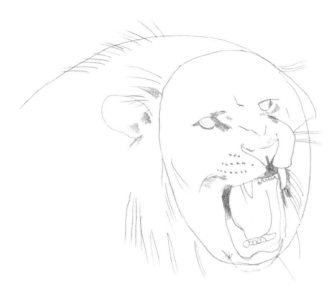

3. *Next, add a few whiskers, dots where the whiskers grow, the teeth and some of the fur. You can see here how the oval shapes soon become a more recognizable animal.*

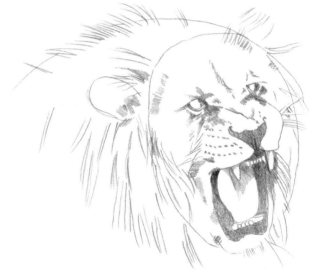

4. *Work around the entire head, adding tones, fur and more details. Where you add darker tones, make sure that your pencil marks follow the direction in which the fur grows, and that they are as long – or short – as the fur on that part of the head.*

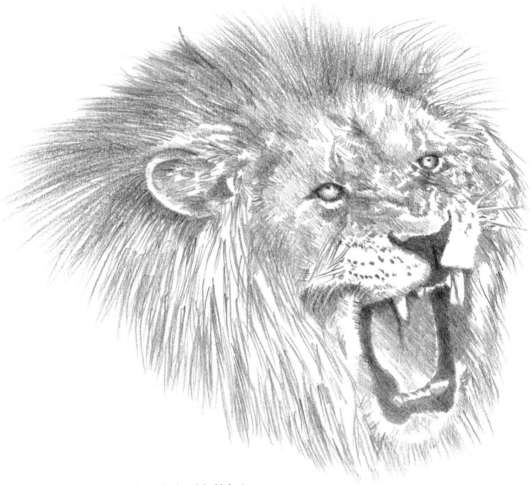

5. *Continue working over the entire head, half-closing your eyes to identify the darkest areas. Use well-sharpened pencils and try not to overwork your drawing. You need enough marks to show the fur and dark tones, but to achieve a sense of light and movement, a light touch is imperative. Lift your pencil off the paper with confidence.*

Practise here:

Index

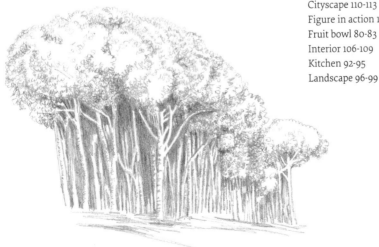